2xIntro:

On the Road with Patti Smith

photographs by Michael Stipe

AKASHIC
BOOKS

All Michael Stipe words and
photographs ©1998, 2011 by
Michael Stipe

° photographs ©1998 by Oliver Ray.
Used by permission.

All other writers in this book individ-
ually maintain ©1998 on their written
pieces. Used by permission.

Originally published in 1998 by Ray
Gun Press/Little, Brown & Company.

Editor: Mark Blackwell

Design and typography: Chris
Ashworth/Ray Gun

Design assistance: Amanda
Sissons/Ray Gun

Design assistance for Akashic
Books reprint: David Belisle and
Aaron Petrovich

Photograph layout: Michael Stipe,
Mark Blackwell, and Chris Ashworth

ISBN-13: 978-1-61775-023-6
Library of Congress Control Number:
2011923104
First Akashic Books printing

Akashic Books
PO Box 1456
New York, NY 10009
info@akashicbooks.com
www.akashicbooks.com

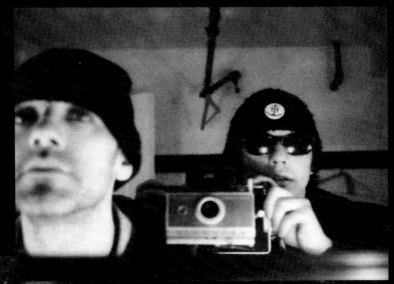

with additional polaroids by Oliver Ray

2xIntro:

with words by William S. Burroughs, Michael Stipe, Oliver Ray,
Paul Williams, Jutta Koether, Tom Verlaine, Thurston Moore, Jem Cohen,
Lisa Robinson, Lenny Kaye, Kim Gordon, Frances Yauch, and Patti Smith.

Patti Smith is not only a great performer, she is a shaman – that is, someone in touch with other levels of reality.
Her effect on the audience is electric, comparable to voodoo or *umbanda* rituals, where the audience members become participants, and are literally lifted out of themselves.
In many cases, however, they are destined "to return to ordinary consciousness" – to be once again the single mother of three small children, or to follow the animal goals of the street hustler...but the shaman has, at least, provided a respite.

William S. Burroughs
July 4, 1997

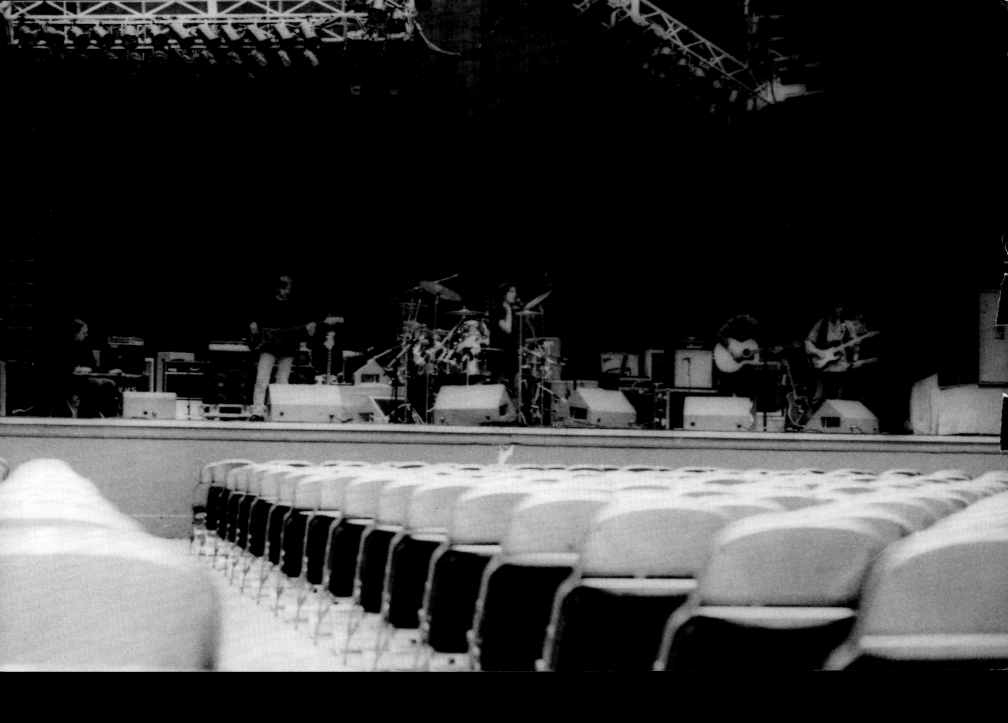

Preface 2011

BY PATTI SMITH

When I open this book I see in my mind two men whose images do not appear inside. The first is my late husband, Fred Sonic Smith. In 1979 I withdrew from the public eye to devote my life to him, our children, and our work. But his early death in November of 1994 obliged me to leave Detroit and return to New York City. The second invisible man is Bob Dylan. He learned of my plight and invited me to tour with him. He encouraged me, assuring that the people would embrace my return. Bob Dylan, as was Fred, is a very private man and although he was often in our presence, Michael never took his picture.

I met Michael Stipe in Michigan in 1995. He had called me on February 14 from Barcelona, Spain. I did not know him, but aware of the passing of my love, and anticipating my loneliness, he called to wish me a Happy Valentine's Day. That was the first time we spoke, and the last time he would be a stranger.

Sometime later, in answer to Bob, I gathered the friends who had helped me write, record, and produce *Gone Again*, an album in homage to Fred. Our ragtag band included Lenny Kaye, Jay Dee Daugherty, Tony Shanahan, Oliver Ray, and Tom Verlaine. Joining us were my children and Michael, our friend and champion. We set out along the East Coast for our tour. Michael made us quesadillas on the bus in a microwave, and eased my trepidations about performing again.

Some of the things that I remember of that time include breaking in a new pair of Doc Martens. An Oscar Mayer Wiener truck that miraculously appeared in the Holland Tunnel. Oliver Ray's poems and Polaroids. The saffron-colored dress Michael bought me, hanging on a hook in the locker room of a Connecticut gymnasium. All of us spending the day looking at Brancusi sculptures in the Philadelphia Museum of Art and being yelled at for touching them. I remember the warm camaraderie of the band. I remember Bob stopping on his way to the stage to speak with my son and daughter. And I remember performing "Dark Eyes" with him, singing so close that a rosary of sweat, dripping from our foreheads, merged as we sang.

I am grateful to have these pictures that resonate such an innocent and bittersweet time. After sixteen years of absence, Michael documented my first steps back and thus my second introduction into public life.

Patti Smith
April 2011

2 x Re-Intro 2011

BY MICHAEL STIPE

This book and the small stories it touches upon mark a very important time in my life. It is, for me, funny and odd to look at it some thirteen years later, and to realize how much has, and has not, changed. People have moved on, some in life and some in death, and others have come in, or been born. Friendships and kinships have deepened and become profound and irreplaceable. Experience and art and music and inspiration have continued their march. The century is a new one and is already peopled with a generation offering insight, new opinion, and life-altering change.

Patti has gone on to produce some of the best music of her life, songs that capture her spirit and energy and love of life and history. It has been a pleasure and extraordinary thrill to see her grow back into this from the modest but exhilarating return to music and live performance that this book chronicles. The need to create is something that many of us share; to be able to watch her create, from this perspective, is blessed. To pull songs out of oneself, stories, narratives, to relay histories learned and lived, to do so with such humor, insight, and detail, is a true gift.

Patti carries in her work and actions a deep intelligence and profound love of life, all infused with levity, humility, chaos, and fine order; and her gift to us is sharing that in all its raw humanity, its curiosity, and ultimately, its grace.

With the worldwide success of *Just Kids*, the book of her and Robert Mapplethorpe's beginnings in New York City, Patti details the innocence of a distinctly important moment in time, and in a voice that no one has managed to sound before. She has brought us again to a new understanding of ourselves, which is the highest calling of an artist: to speak of their times and to do so in a manner that illuminates and alters the course of the present.

I am thrilled and humbled by the attention *Two Times Intro* has received, and I thank everyone involved in its being reprinted today. Special thanks are due to Anthony Arnove, Susan Bodine, David Belisle, and Oliver Ray, and to Johnny Temple and Akashic Books for their interest in publishing this book.

Michael Stipe
April 2011

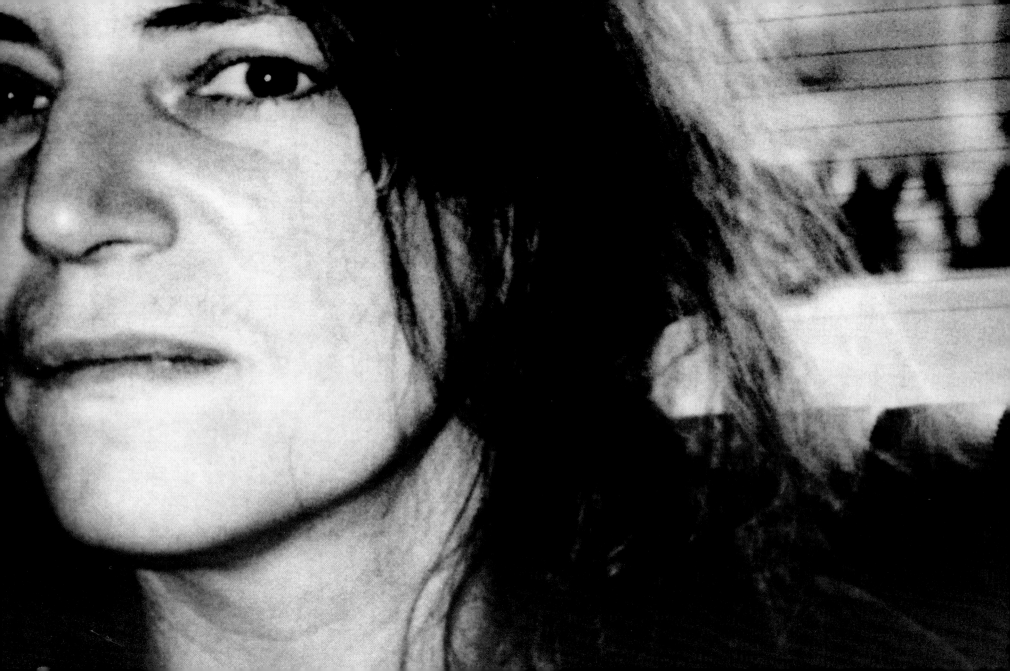

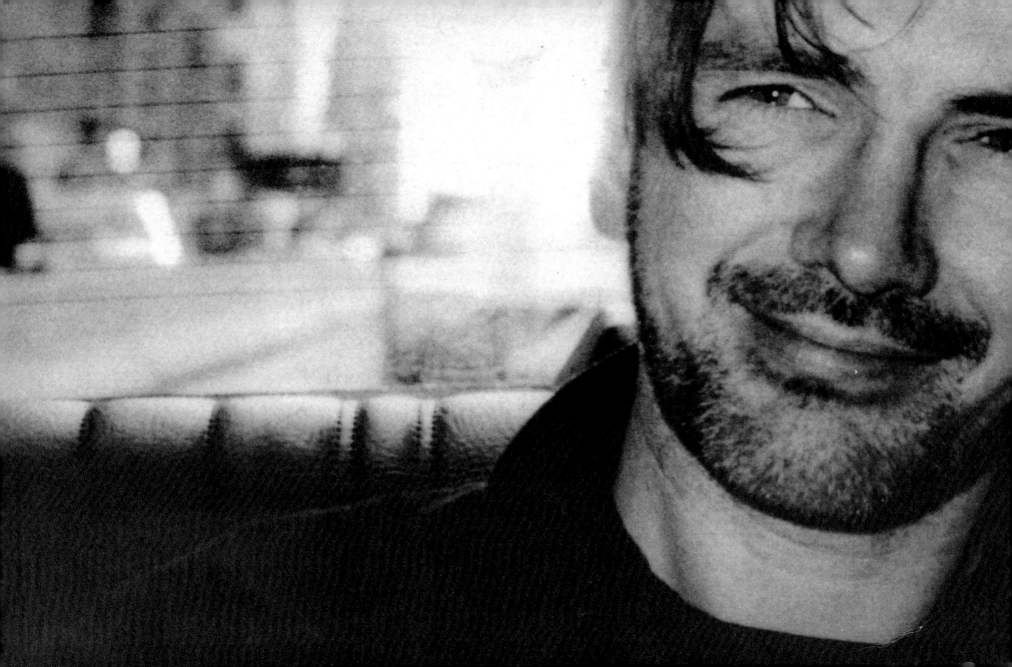

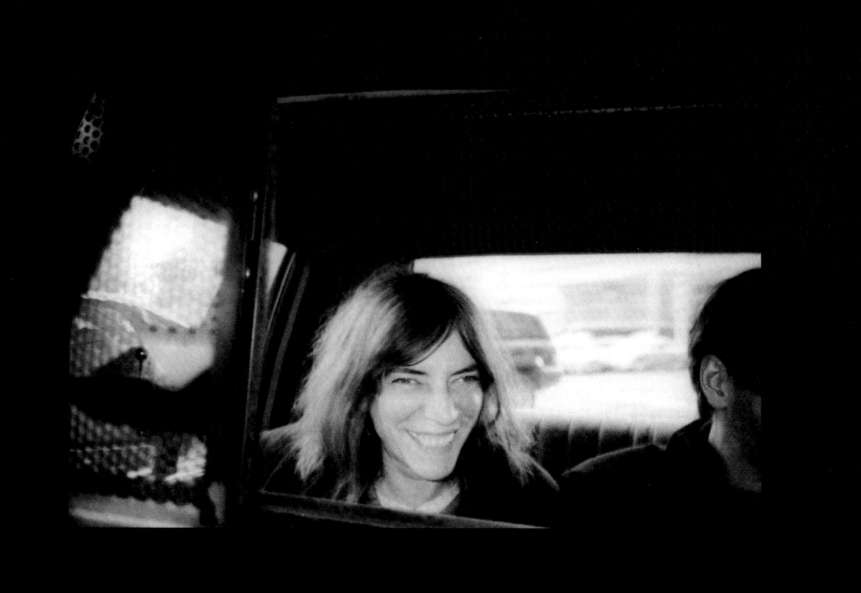

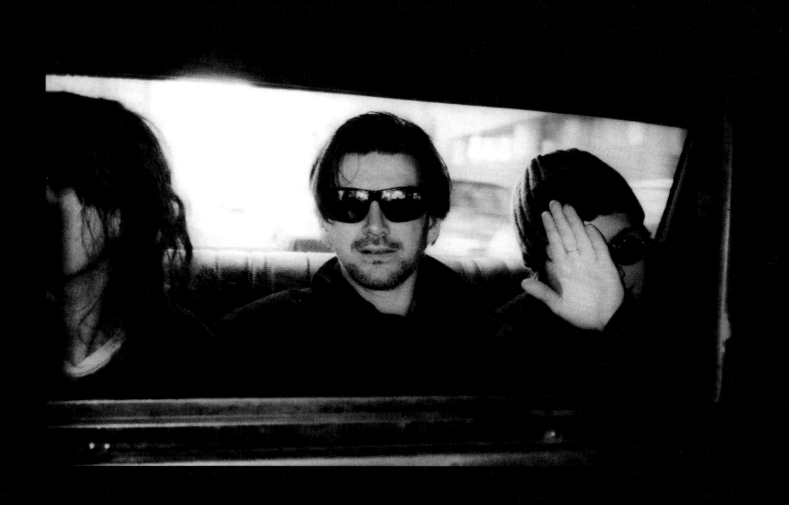

2

2xIntro is when the singer comes in.
20 years later here I am.
abstracted vs. personal.
never meant to be a photo book.

2xIntro is when the singer comes in.
In writing and performing pop songs,

you pretty **much** find the hook and

repeat it twice before you introduce
the vocal – two choruses or two of
the guitar parts that go through the
verse and you're off – that's the
formula, that's the general rule. All
this – this book, whatever I've done,
whatever she's done – is kind of
about breaking the rules, and
working within them. This is about

inspiration, and where it can take
you.

I first met Patti Smith in the autumn
of 1975. I was in detention study hall
at high school in Collinsville, Illinois,
outside of East St. Louis. I was 15. I
was a dork nerd. I didn't want to be

there. Somebody had left a music
magazine, *Creem*, under the desk
that I sat at. I started reading it, and
found an article about a new scene
that was developing in New York
City. At a bar called CBGB's, bands
like the Patti Smith Group and
Television were creating a local stir,
and starting to attract fringe music
fans. Though I was far away and had
nothing to do with any of this, I
immediately felt a strange connection,

some outsider teenage pull – not to

Intro

sound like "this is my church" – but

it was like a Mack truck dropped on me.

The writer of the article, Lisa Robinson, said that the music and style of these bands was like b&w TV, scratchy and raw and stripped of

color, visceral and vital, radio-static and intense. There was a haunting photograph of a young Patti Smith, leaning against a wall, staring down the camera, all scary and beautiful. It was astonishing. I was mesmerized.

I hounded the record store and bought her first album the day it came out. It was mindblowing – emotional and imperfect, swirling, b&w. It was so direct and real. I went on to buy Television, Wire, The Velvet Underground – there was a world of

music to explore. I felt disconnected from the popular music of the time,

but here was something that spoke to me. For almost two years I was

alone in my love for this stuff – I was still an insecure nerd, but the music gave me a sense of strength. As Burroughs wrote in the preface, I felt "lifted out of myself."

I was taking a class in photography

and borrowed my Dad's 35mm cam-

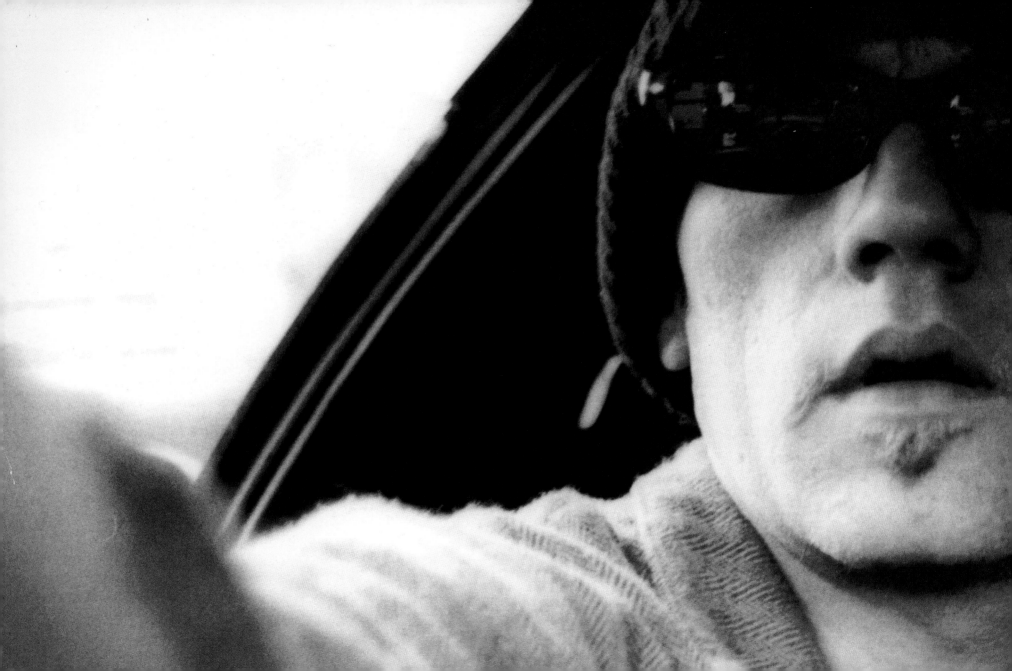

2

era and started taking pictures. I answered an ad, joined a band, moved away, answered another ad, quit, got a job, started my own band in 1979; and by 1980 I was writing okay songs and printing my own photos in the kitchen of my rental, using stolen developer and a shitty enlarger.

I met Patti Smith in the summer of 1995 in Detroit, and several times subsequent, and we became friends. She had pretty much abandoned live performance for near on 16 years and was considering doing shows again. I was on tour with my band, R.E.M., and had spent the last 15 years performing live and making records. On first meeting her, I stated my long admiration for her work, and how profoundly it had influenced me and the direction my life had taken.

It must have bored her to tears, but it had a leveling effect. It allowed our past together – my past – to be put away. I could see her for the person she is and not as some distanced heroic influence. She would not have to guess my interest or allegiance. And we could get on with the present as two people whose experiences and work afforded us a great deal in common.

That November, Bob Dylan invited Patti to open for him for several shows in the Northeastern US. She accepted. Dylan had been a huge influence on Patti, and it was significant in that she had not toured

Intro :

with a band for almost two decades. I was in New York and Patti asked if I wanted to come to a few shows. I said yes.

It was kind of a mistake that I wound up on the bus for the entirety of the tour. Dylan added several shows to a successful run, and so I jumped on Patti's bus in Manhattan and what was supposed to be 4 shows turned into 12 or 13. Half the way through I was having so much fun I thought why not finish it up, and so I did. I had my cameras, as I always do. Oliver Ray, guitarist in Patti's band, had a old polaroid and was excited about learning how to use it. A lot of pictures got taken.

The combined bill of Dylan and Patti was phenomenal. They obviously had great admiration for each other, but what might have been great became instead transcendent – a kind of inspired and benevolent boxing match. I sat stageside or backstage with my camera, watching and taking pictures. This is my photo diary of those 2 weeks. It's what I saw.

I can only hope that the inspiration that made this book possible will carry on through words or pictures, or music or laughter.

All the best and thank you for looking.

Michael Stipe
August, 1997

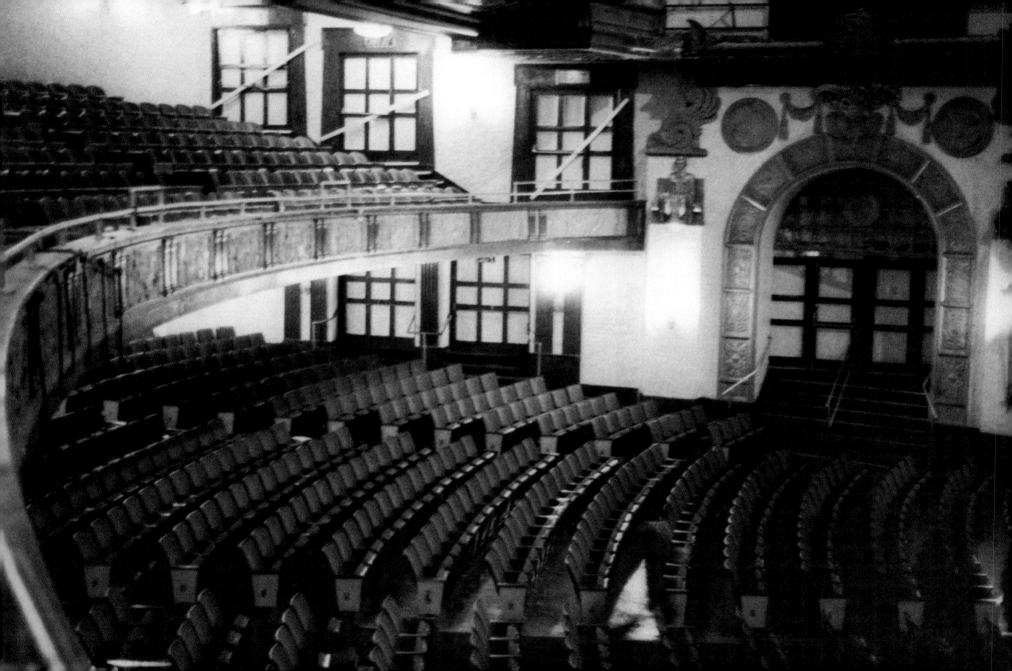

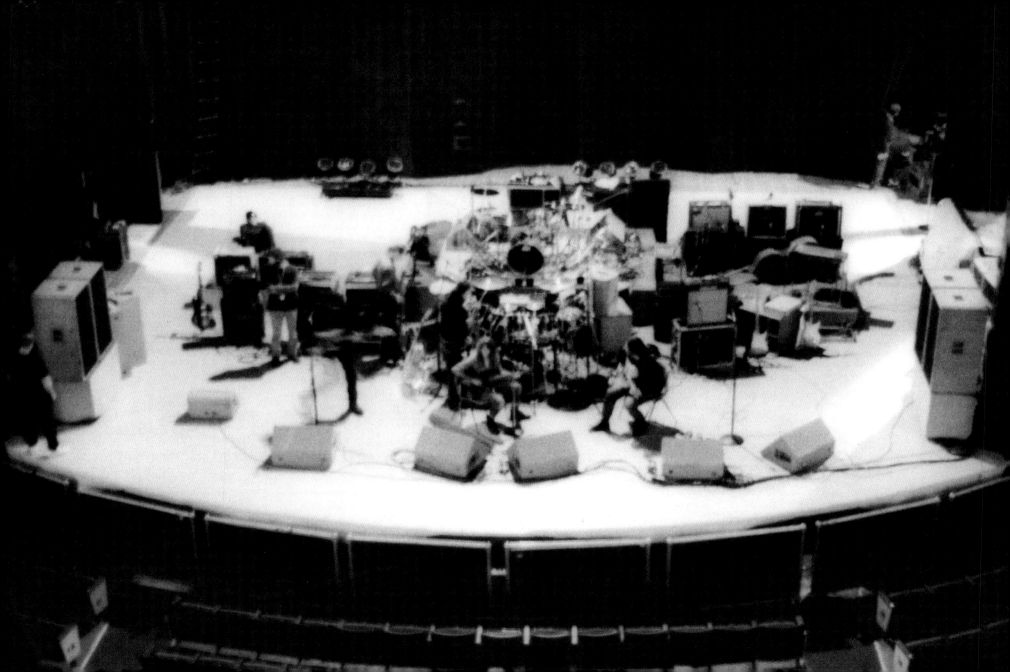

o

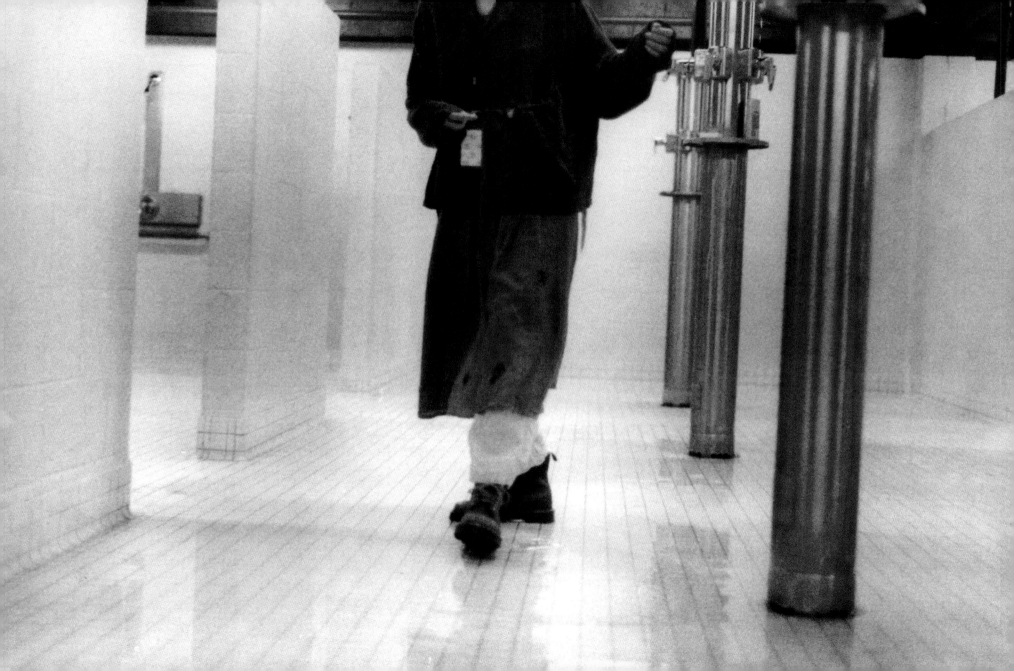

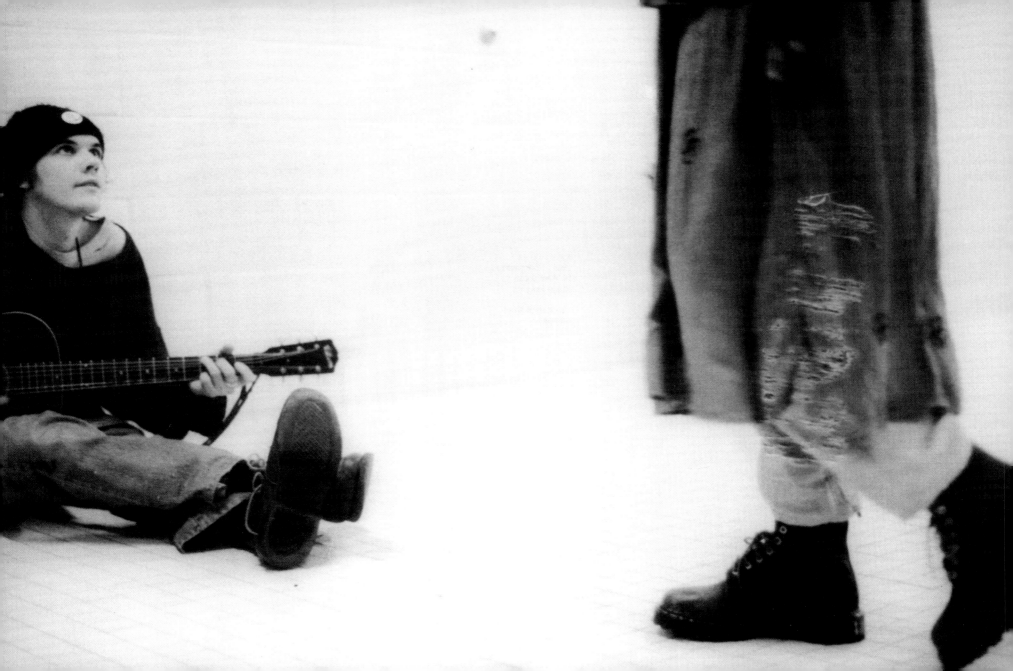

Where I was shooting from....

There are so many ways to shoot and we are shot daily with and at by scores leagues of battalions of soulless images like the armies of Kama Mara and the artists' job is as the Buddha did by summoning the very spirit of mother earth beneath the unmoveable spot upon where he meditated to turn the missiles of illusion to flowers.

Found the camera in an old camera shop on the outskirts of Detroit. Patti has one also; decided to get my own: Polaroid Land camera automatic 100 – cheap, simple, and easy to manipulate. We went to New York before the tour, got a whole bunch of 667; put it in a cardboard box, threw it on the bus.

Polaroid might here be likened to Rock and Roll. It's fast. The result comes quick – the gratification near immediate. And if you can sustain it you can reach heights

of sophistication (if that's for what you're looking).

Oliver Ray

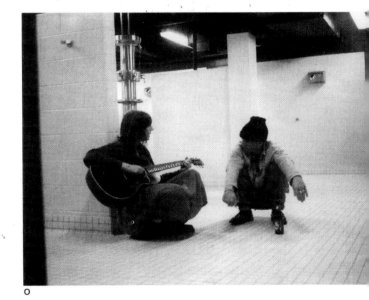

O

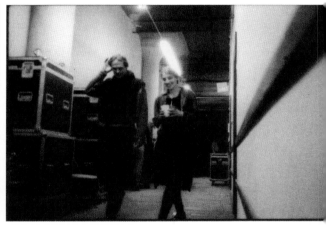

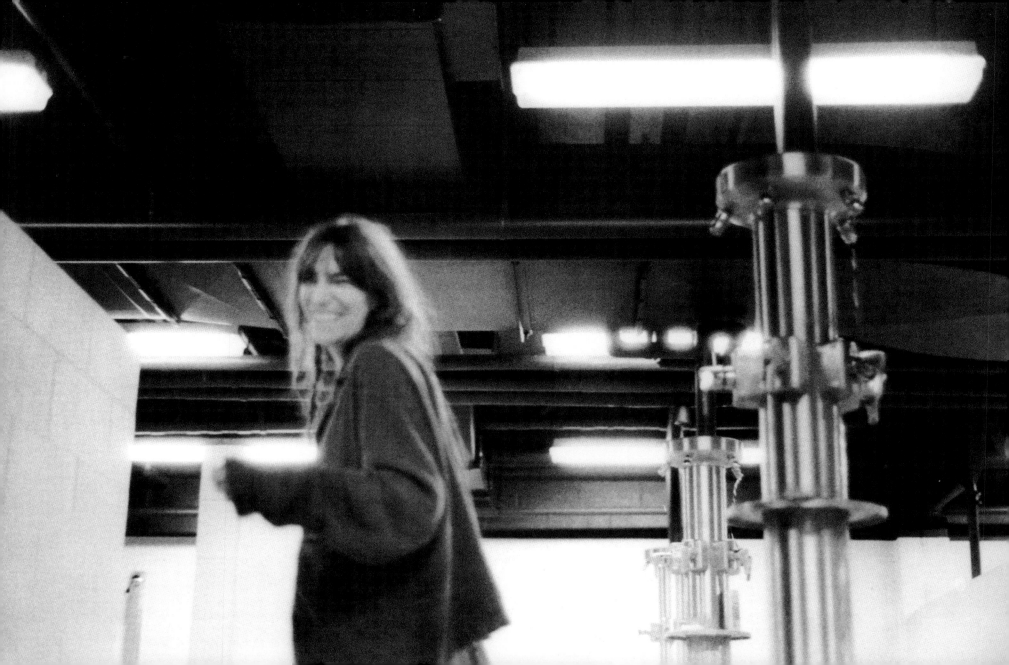

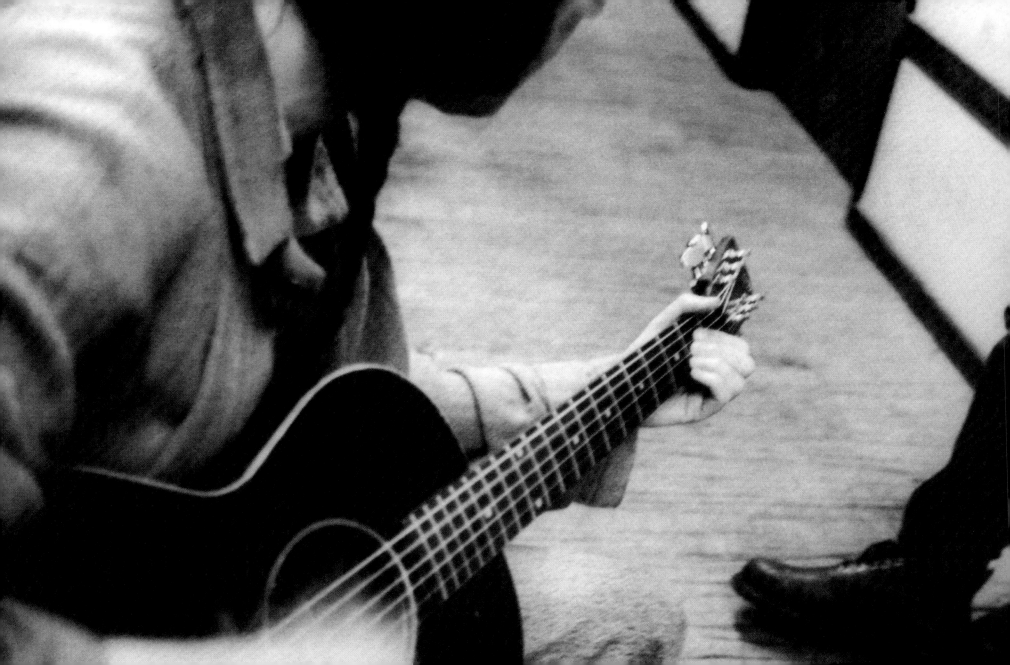

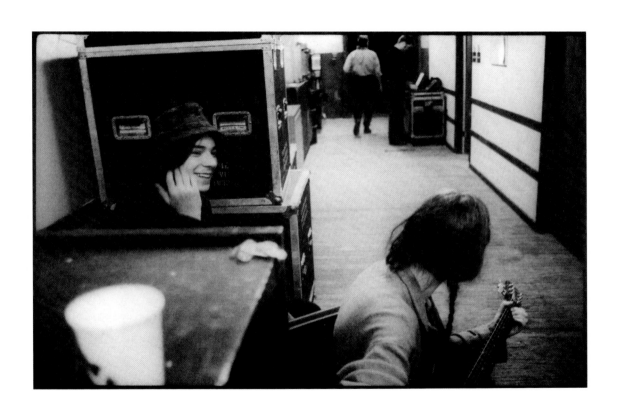

o

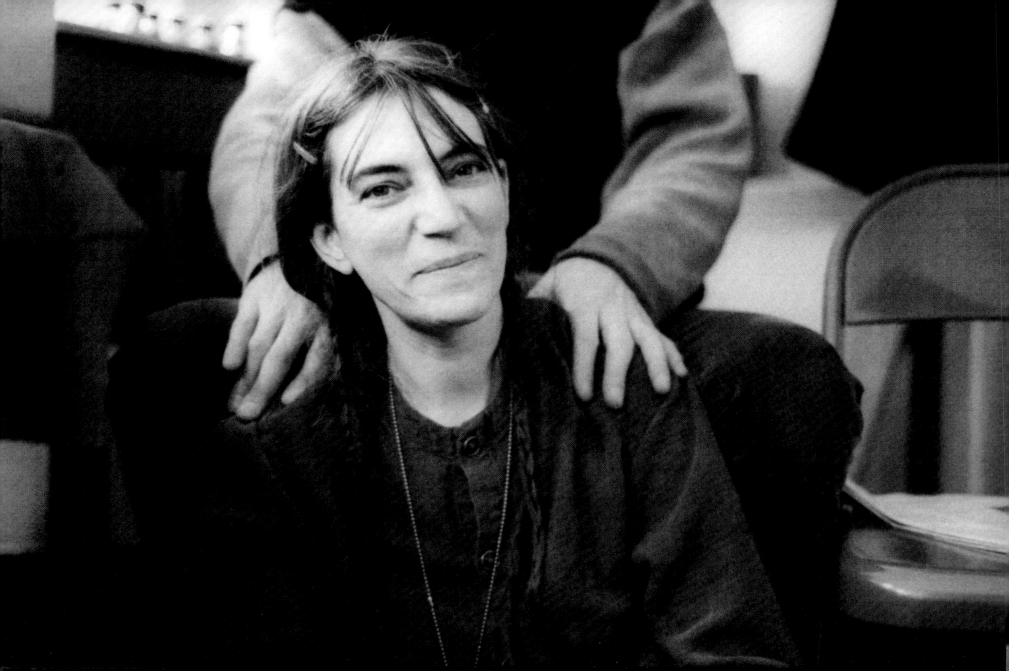

O

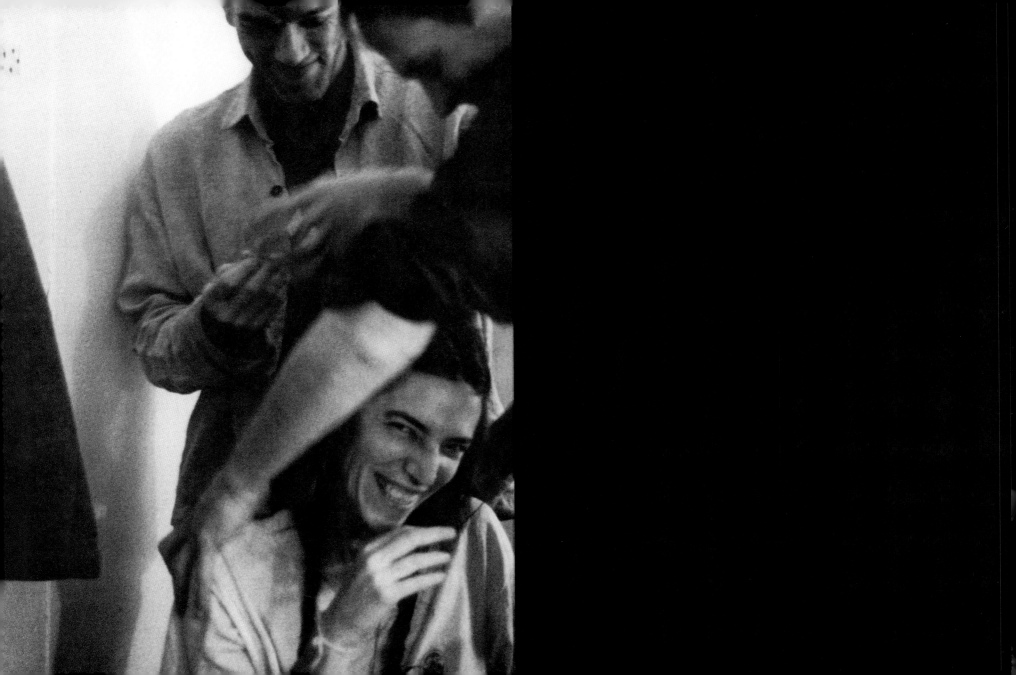

"Paths that cross will cross again." What a gathering of the tribe....

"All you guys together is great too!" Patti Smith shouted to her audience the first night of the Paradise Lost Tour. She was responding to an audience member who'd shouted out how great it was to see her and Television founder Tom Verlaine and Patti Smith Group veterans Lenny

Kaye and Jay Dee Daugherty on

stage together. The shouter was presumably also excited that Bob

Dylan and Patti Smith were on the same bill, if not yet the same stage, for the first time ever. And Patti was cleverly acknowledging that it was also a coming together of core audiences.

Two nights later, two excellent

performances later by my two favorite live rock performers and their bands, I was fortunate to be present when Patti came back up the long backstage stairs in Boston's old

Orpheum Theatre after her first conversation with Bob Dylan on this tour. She sat, and as Michael Stipe braided her hair affectionately and skillfully, she told us about the encounter.

(I had just met Michael a few minutes

earlier when he asked if he could take my picture, a very polite paparazzi; and while Patti talked and Michael braided I stood and watched and listened beside Allen Ginsberg, whom I first met 28 years earlier when we were sitting in the same box at Carnegie Hall watching Bob Dylan's first post-motorcycle-accident performance.)

Patti told us Bob had urged her to

take an encore after her set because, he said, the people clearly wanted her to. He also brought up the subject of him and her singing something together, and she'd told him she wasn't sure she was ready.

It was the last time I saw Allen. While Patti was downstairs he enthusiastically told me the story of how he'd unexpectedly found himself performing a few weeks earlier at the

Royal Albert Hall with Paul

McCartney backing him on guitar (to the audience's delight) as Allen sang his new mini-epic "The Ballad Of The Skeletons."

"Paths that cross...." The line is Patti's from her magnificent *Dream Of Life* album. She sang the song

occasionally on the tour. As she and Bob sang his "Dark Eyes," beginning the next night. *With feeling.* "A million faces at my feet, and all I see are dark eyes." But backstage is a different kind of magic, as these photos record. I watched Tony

Shanahan over in a corner teaching

Tom Verlaine (my guitar hero since *Marquee Moon*) the chords to "Rock N Roll Nigger." Paths that cross.... I ran into Allen another time at another gathering of the tribe, we both were

pleased to be seated near Albert

Hoffman, discoverer of LSD, at a dinner table at a 1977 conference commemorating that discovery. And I was only able to be in Patti's dressing room now because Lenny Kaye and I are friends since our paths crossed as teenagers at a science fiction convention in the early '60s.

What it mostly takes to be present at a great moment is to have the impulse to go down to the show, and then to follow one's intuition. I can't

help but remember a day at the end of June in 1975 when I had the

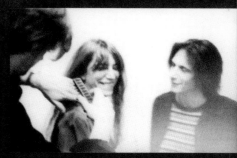

impulse to finally go see this Patti Smith my friends had been telling me about. At the Other End on Bleecker

Street, I found myself sitting in a booth next to Bob Dylan's, another music fan who apparently had had

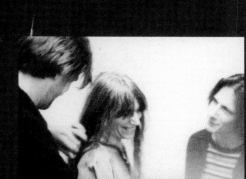

the same impulse. Patti and her group were great that night, and Bob went backstage to congratulate her.

It was their first meeting. For some

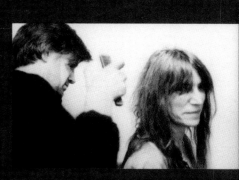

reason I found myself there, I guess so I could brag about it to you in the pages of this memory book. "People take pictures of each other, just to prove that they really existed." Ray Davies said that.

Paul Williams

See you in Gelåzenheit.

There is art. There is grace in momentary associations forming

space, changing order. Becoming trace, leaving traces. Walking away, walking around, not "coming back." Publicly playing these ways of not coming back. Gone again, that was offering those directions to get lost, as they say, aspiring to lose

oneself in what is shown.

Lots of fine detail within. How I liked the moment featuring the wearing of a dress.

"The goddess is recognized by her walk," said Vergil. There were golden boots. "...he felt the female & c," said Blake. The art is to make the most of the "c". Consolation for a mind, and songs from heart and history.

Time of transports and traces, some modulated by pain, some by the enjoyment of life, and by "letting it

be," yet slices of that optimistic affirmation, on the vehicle, rock-music-stages.

Space expanded through tributes to,

and actual contributions of friends, helping to bring the tracing of methods and styles alive, handmade tracings, changing lively every night, sounding through and with the words, gestures, messages that make the fabric of feeling. Walking through space, the walk of all the

possibilities, the little "c", including the caring for it all.

Tensions, tunings, bad picks, post-show-dinner. Yet from behind that braided hair I get the message, that whatever there is, the moment tells of a passion of what IS and there are various people and forms involved in it. It is not all the focus on a person, but her love for the dynamical sublime, celebrating translational moments, references, jokes, and bringing in different generations of

musicians and friends, son, daughter, sisters, mother, with that a sense of history and that sense of some love that loves us.

Pointing me out the space, where to-want-all and to-want-nothing coincides beautifully. Like a jewel, that likes to be not too polished into the eternal New, but shining with all marks of transgression it acquired through history, bodies, deaths, shiftings. Gelåzenheit. Then again... all is imaginative. Real laughter too.

Images. Always memories. Amplification. Enhancement of "the inner is what depends on us" (Plotin).

Well, get the documentary glimpses from an "inner" country, like a map of that space, series of sites, "Carte de Tendre," tending toward that black page from which one can relearn to see them pictorial, and other skies, well, I do.

See you there.

Jutta Koether

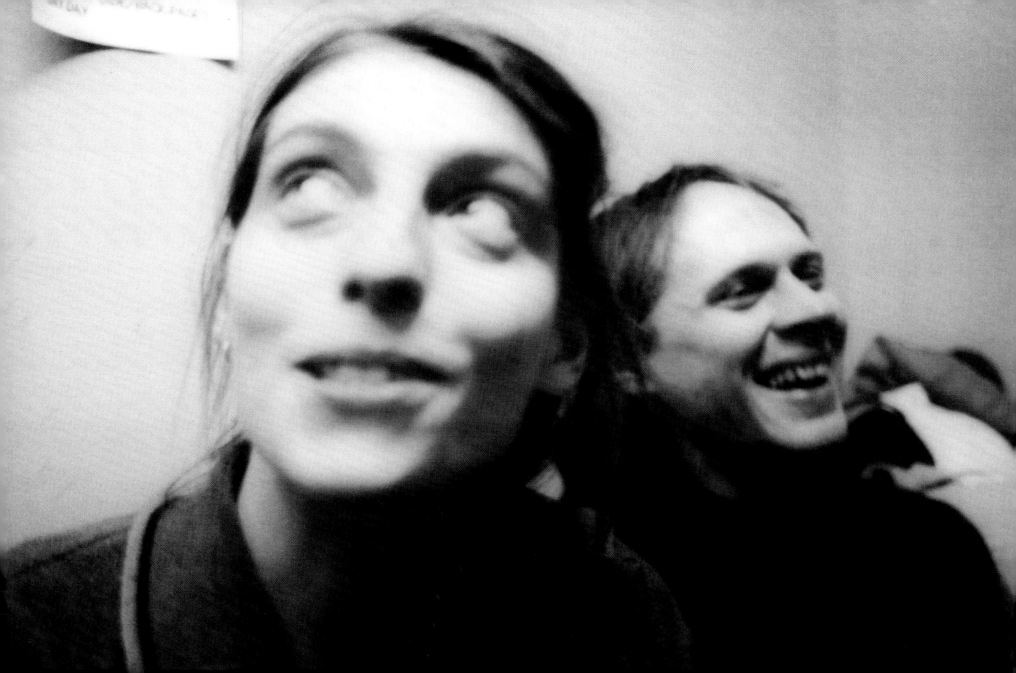

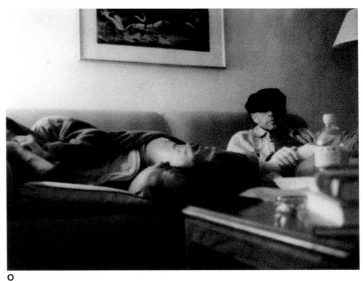

O

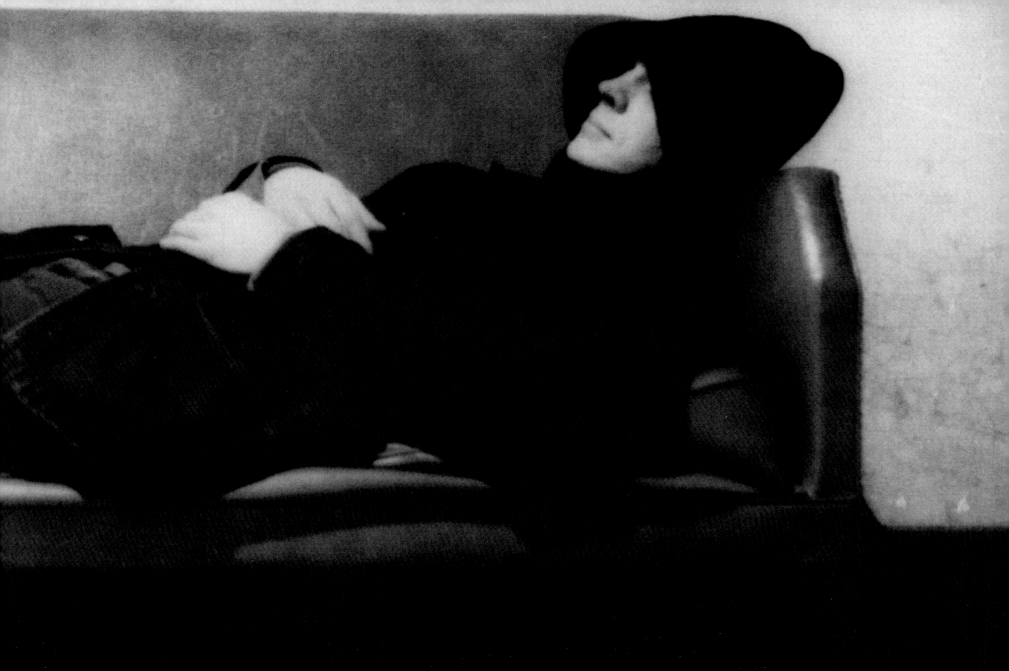

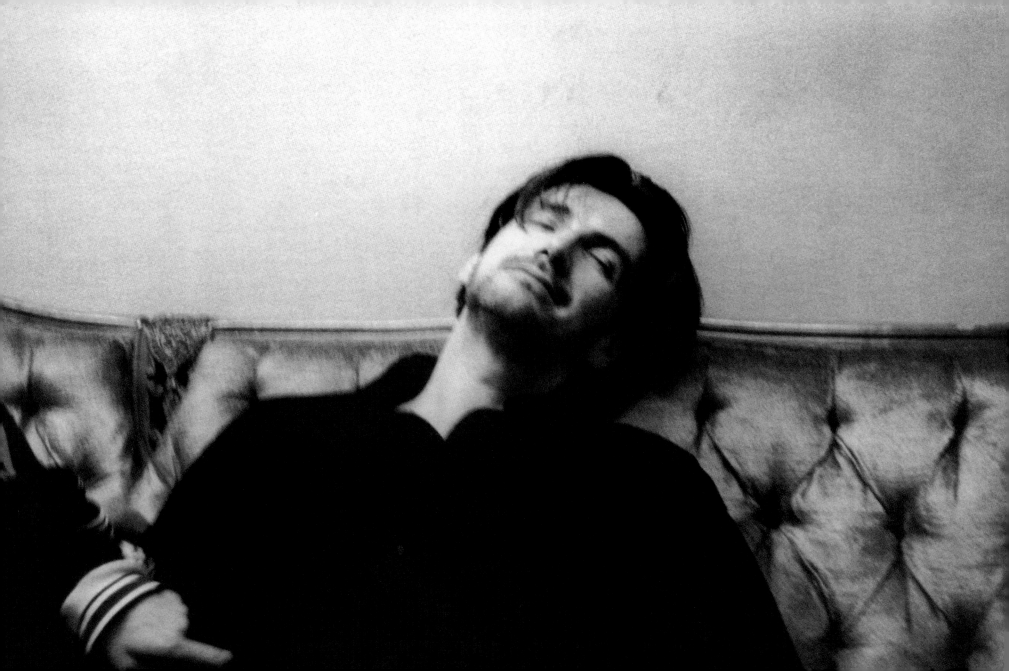

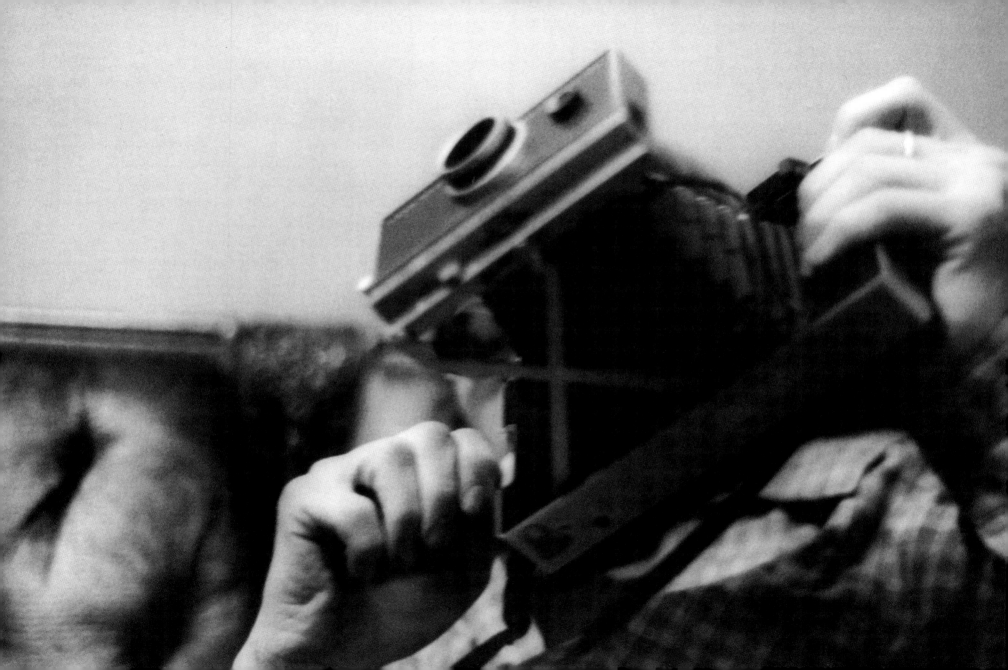

December

I'm thinking of bells alot lately.
Big bells.
and snow.
Then a week later,
a snow storm most of the night.
and, The Liberty Bell!
So silent! Silence!!

Tom Verlaine

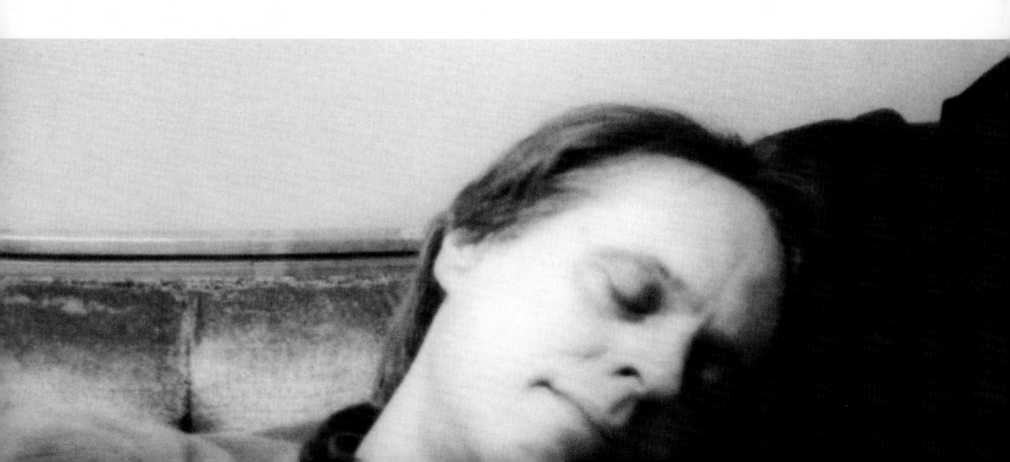

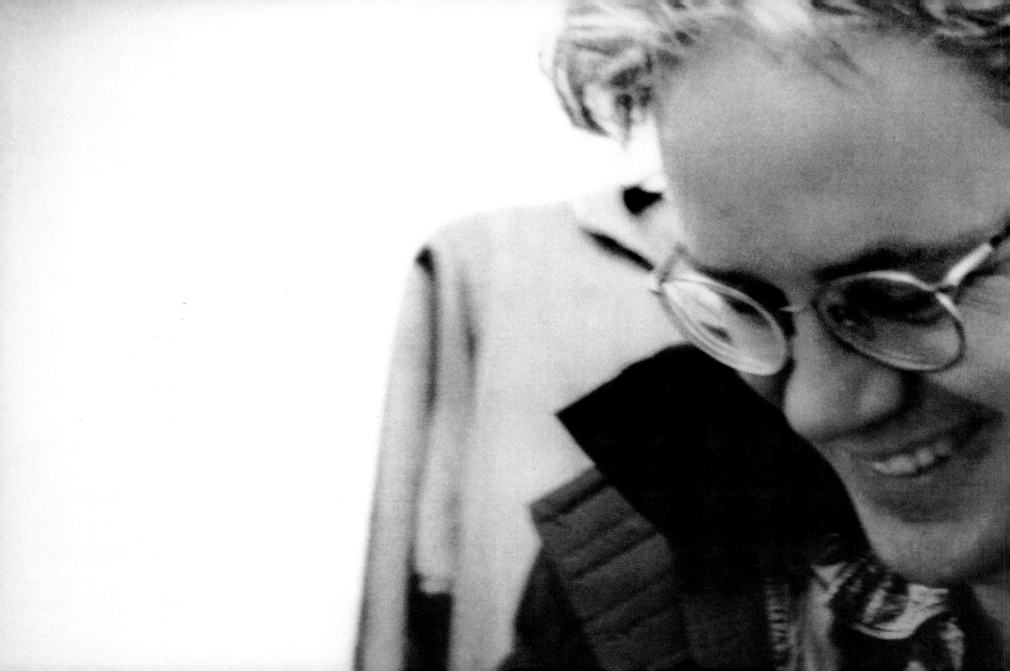

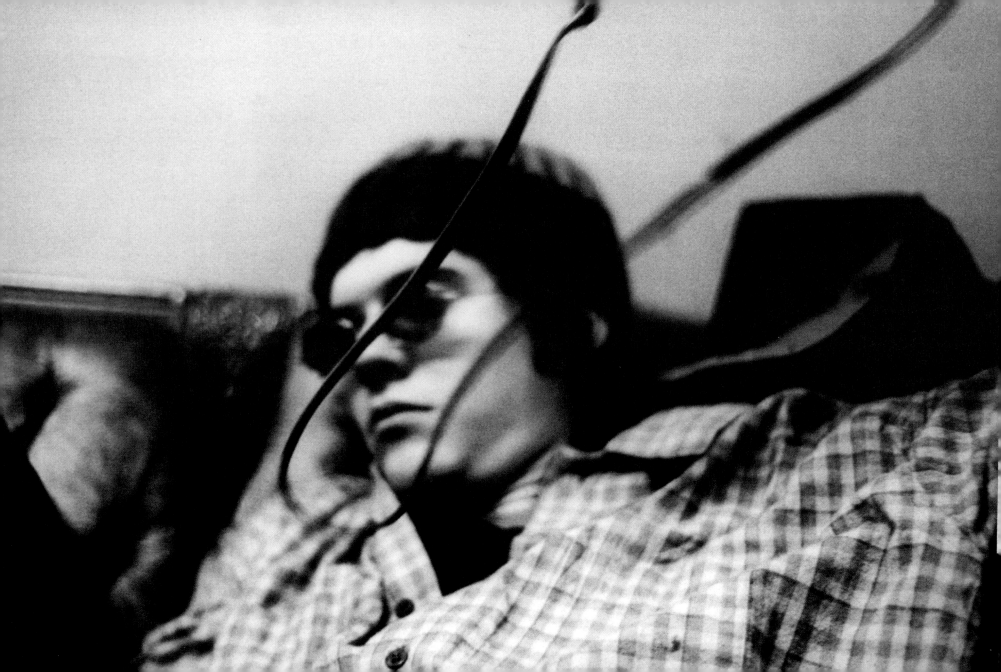

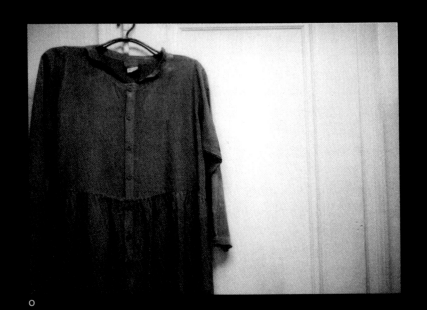

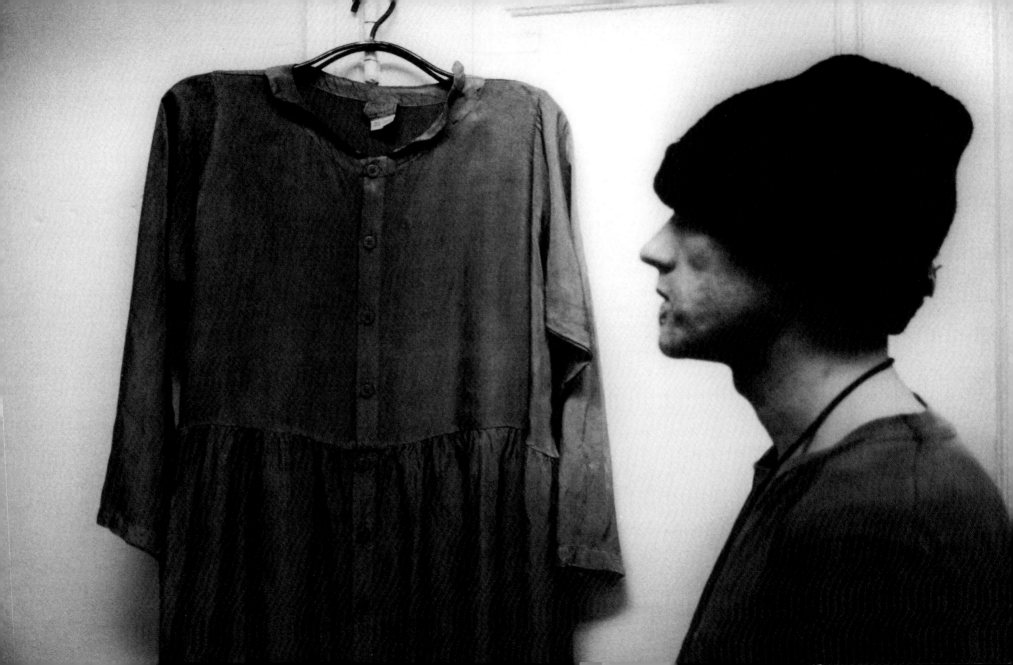

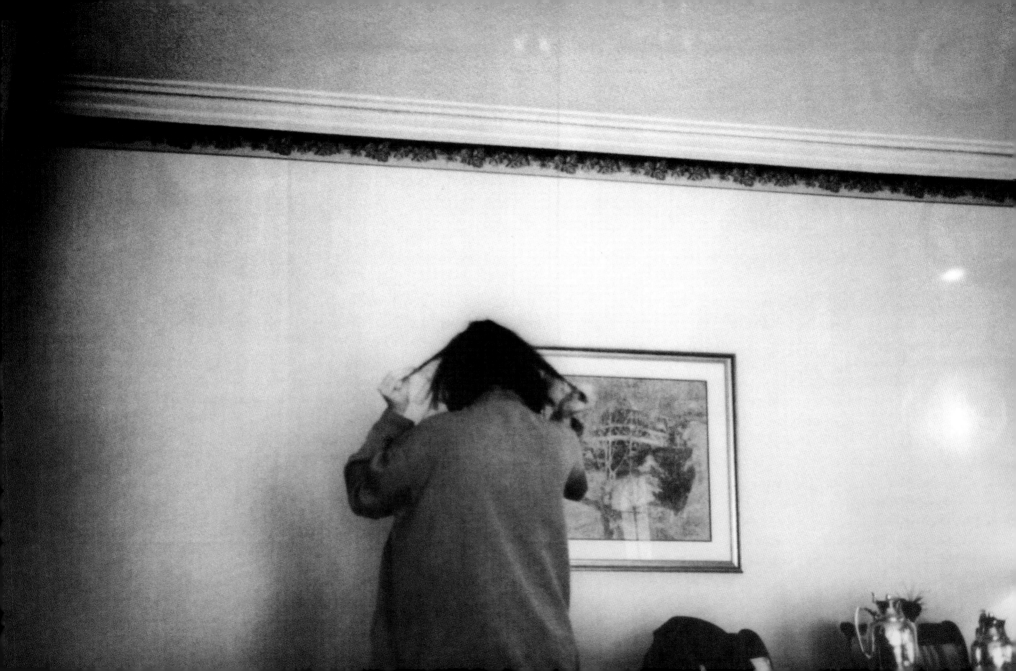

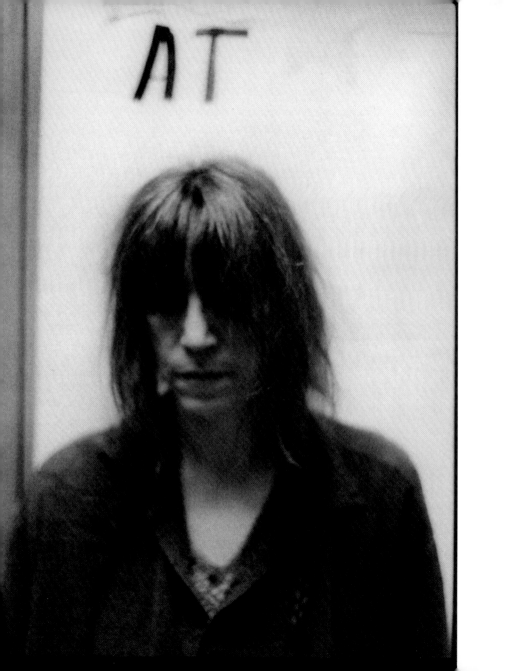

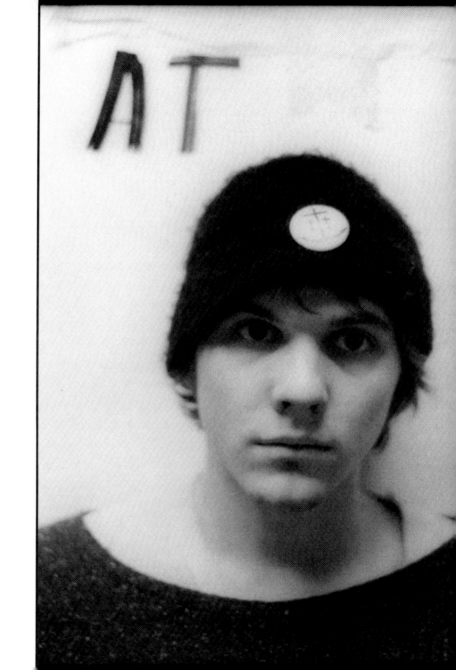

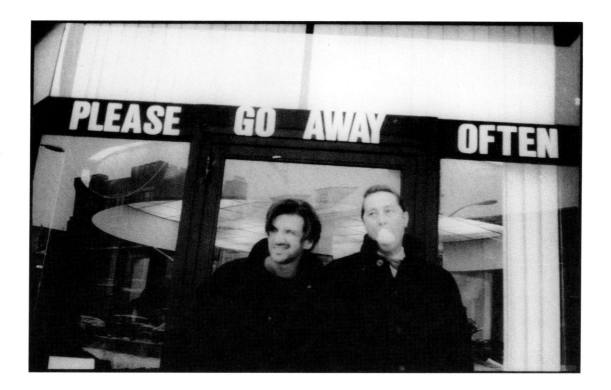

FANTASY FUCKS REALITY SUCKS

michael (stipe) came with us (sonic youth) to see (wm.) burroughs in the early spring of 95 while we were touring w/ rem. we'd met burroughs once before a few years prior. he lived in lawrence (ks.) in one of those 1950s sears fold-up houses. we were enthralled to be in the man's house as his guests. his perspective on life both real and magical had made quite an impression upon us. but burroughs only spoke of knife and

gun collecting. no one in sonic youth had any real interest in these subjects. it was nice to meet him though. I related this to michael as we headed to lawrence for our second visit. I was hoping to have more of an open conversation about things other than hand weapons. michael said he had just talked to patti (smith) on the telephone. he was inviting her to come see rem in detroit. to me, more than any influence on my creative life – burroughs, iggy, hell – patti was the

heaviest, the most mythological, and the most alien. I could not imagine talking to her face to face. she held a complete and striking place in my heart. as a 17 year old in 1977 I attended every nyc (and connecticut) performance she gave and there were many. she was unstoppable and undeniable. she approached her work as an artist, musician, and poet with such an awkward and sexual grace that I knew immediately, more than ever, what to do with myself from then on. I moved to nyc to play

rock n roll. michael's the same age as I am and he said it was the exact same thing for him. he adored patti. he identified himself through her music. as impressionable punkrock teenagers we were fucked. patti split nyc and we grew up and worked hard and we got to meet all our beautiful heroes. all but one – the most beautiful. in 1995, through circumstance, she was coming out to play again and we were gonna be there welcoming her totally ready to kiss her feet. she'd probably think we

were assholes. michael and I looked at each other with such a feeling of the unknown. it was like we were gonna go to mars. well he was at least, sonic youth weren't playing the detroit gig. but we were gonna do lollapalooza that summer and rumor had it she was going to play the new york show. anyway we got to burroughs house and burroughs immediately freaked out at michael as michael proceeded to throw his hat on a bed. this is bad luck but burroughs caught him just in time.

burroughs really liked michael and they chatted quite a bit. I pretty much sat munching the tea sandwiches made available. I heard through someone that patti went to the rem gig and michael sang the whole night facing where she was standing and that she completely rocked to the band. I met her at lollapalooza. she arrived in a van with her band and two kids (jackson and jesse). I stood there watching her and I noticed some business person go up to her and point at me! she

was being brought over to me and we were introduced and...well, we became friends. she was a human being mom believe it or not. she took no crap and played a great fucking set and she hugged me at the end of the day before she split. now this was a moment that I had possibly waited for more than any in my life as a rock n roll guy. was it sublime? yeh, it was. I still feel happy from it. later in the year I spent a weekend with patti and lenny kaye up in lowell (massachusetts) where we played

music together in celebration of (jack) kerouac. this was wonderful and I will never forget it but I was talking to michael the other day about certain ruminations on patti re: this book and I had to relate a somewhat confounding personal moment. The first night in lowell me, patti, and lenny sat in my hotel room late into the night. I was interviewing patti for an art magazine in nyc and I was completely tired, burnt out, and headachey. patti was gung ho telling amazing stories about imaginary pet

worms and early rock concert memories and we were having a drink and having a smoke and...this was a moment that when I was 17 in 1977 it would probably be the most complete and utter fantasy ever. but...I wanted to go to bed. I wanted those guys to split so I could sleep. reality was fucking over my fantasy. how could this be? the next day we walked around kerouac's grave in a misty brown leaf graveyard and then we went into a noise record store that I knew about and the owner

made a cynical sarcastic comment about why he didn't see the patti show the night previous *("there was something on tv I wanted to watch....")*. I don't know if patti heard him but it freaked me out. cuz, you know, patti's my friend now and if you fuck with her i'm just gonna have to fucking kill you.

the end.

thurston moore
nyc 10/17/97 2:30am

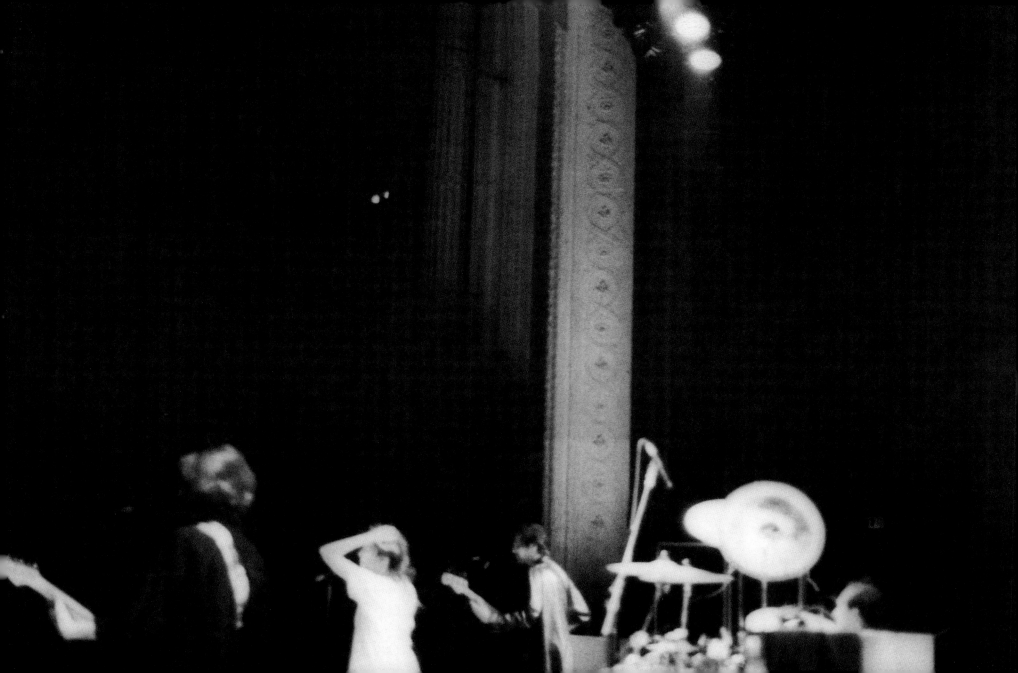

opping

Because
dancing barefoot
wicked

Walkin Blind
~~about a boy~~

Because ———— Perfect Moon
Dancing
Wicked Mess
about A BOY
ghost dance
Walkin Blind
R + R

Fade

Because
Dancing
Wicked
bout A
ghust d
Walki
R + R
F

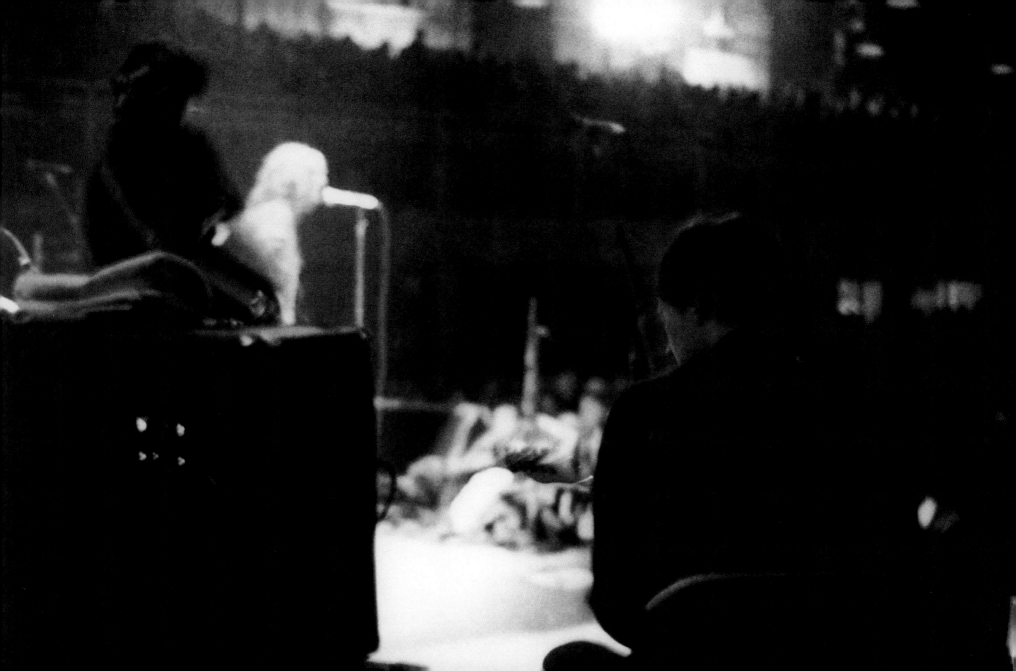

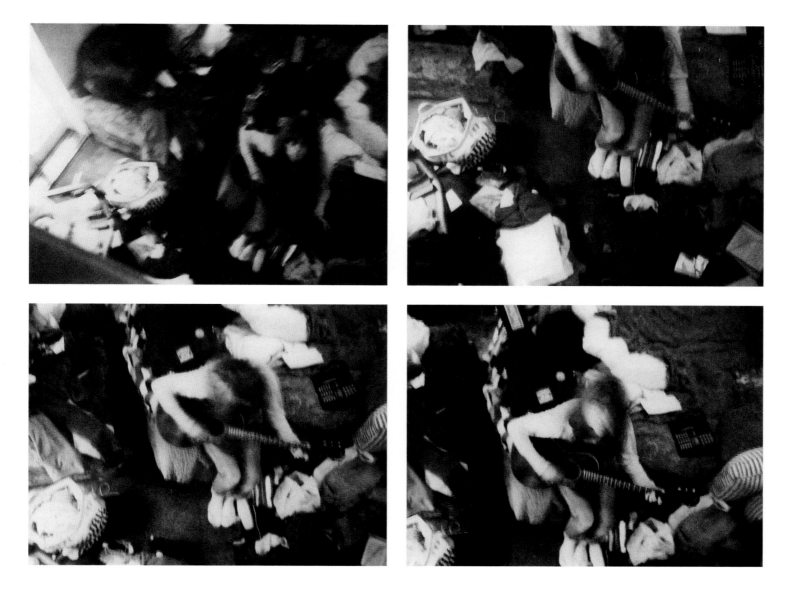

°**x4**

1st year of high school, 1978, I remember standing in a record store holding the *Easter* LP and hoping I wouldn't get caught staring. I liked Patti Smith's music, but didn't know much about her. It was the kind of music you'd only hear on very *rare* occasions at high school parties. And you wouldn't hear it for long because someone "weird" would've snuck it on the turntable and a group of other people would get up and

take it off. Same thing that'd happen with Iggy or the Velvets – an undertow feeling you could sense come into the room, and battle lines drawn around the stereo.

15 years later, my poet friend, Todd Colby, shows me this videotape he'd gotten of Patti on the *Mike Douglas Show* circa 1977. There it is again, that feeling, coming up through about 30 generations of bootlegged,

passed-along VHS tape. Patti with the neck brace on, singing "Free Money" like someone from another planet, or someone who'd casually slipped through the security of Mike's planet. We send it to Stipe, having no idea that it was a tape of the very show that he'd had to miss many years before, being pulled away from the TV in St. Louis at age 17 to go to a family funeral.

Almost 20 yrs. on, and Michael shows me his contact sheets from

this Patti Smith tour. I remember feeling right off that they were some

of his best pictures. It felt like a body of photographs, not of events, but of a time that was deeply connected and happy. You could see it then in his face and bearing. His whole experience of having met her after all those years of quiet influence, then getting to know her, and then being able to hang out on her tour was weighty, but he seemed lightened by it.

Influence is a little like weather, working on both massive and invisible planes. There are storms that take out power lines, and then days and weeks when people don't notice that they *notice* changes in the temperature. It's not impossible for people who most influence an entire generation to wind up strangely invisible to many in that generation.

But that influence can also circle

around and sneak up on things. I know of two young boys in particular, Michael in St. Louis and Benjamin (of the Georgia band Smoke) who heard Patti Smith and fully felt the power lines go out. Benjamin left rural Georgia at 17, found himself working a mop and broom at CBGB's in '77, and went back south to front a wild line of underground bands. Michael came to Georgia and found himself in R.E.M.

Of course, Patti herself is no stranger

to hidden circles of discovery, loss,

and return. Still, all the commentary of the last couple years about Patti Smith being "back" put me off a little. It carried the implication that because she'd been out of sight she hadn't existed. (How could people who aren't in shiny magazines possibly exist...?)

So she was off living her life, having a family, raising kids, writing, reading, working, probably burning stuff on the stove. I like it that the rock world didn't own her, that she chose to

step away for a while and into other things. That she was back here, not as a saint (boring job-description) but as a mother, a working artist and, unavoidably, something of a legend,

made it even more interesting. None of which would've mattered so much if the music wasn't there – but it

was. Her voice might have been better than ever before, and the live show was amazing. Patti Smith's return to public music-making around the age of 50 was blessedly free of that rock & roll hall of fame wax museum sensibility that says, "wasn't this band once great and isn't it wonderful that we can finally honor them now that they're clean

and safe and please proceed to the gift shop...."

Lollapalooza 1995. In front of the main stage thousands of kids mill and tumble in the heat, but seem strangely oblivious to much of the music. On the side stage periphery, a small, joyous and unadvertised comeback show. Here, a fierce small town buzz of celebration. I watch

and shoot Super 8, missing on film the moment where Patti peels off a plain and not necessarily clean-looking sock, and then shoves it down the front of her pants. It is no rock & roll move I've seen before or am likely to see again – automatic, uncool, cool, small, triumphant....

There's a similar rhythm in the way she writes and the way she moves on stage. Sometimes smooth and sometimes with an awkwardness, maybe an adolescence – in the best

sense of the word. She can shift into rage or trance or goofy humor in the same set or paragraph. It gets real serious, takes a left turn, drops down to earth with a satisfying clunk, and then takes off soaring again. Some nights it takes a while for the

band to hit their stride, to get gone, to get off. You can feel the work and the build. The audience pulls for

her, not because of any sensed weakness, but out of brotherhood

and their own need to get lost. The first time I saw her live, giving a free reading in Central Park, she was nervous and lost a poem in the ragged pile at her feet. Immediately, someone's paperback, opened to the poem, was being passed through the crowd to the stage, hand over hand over hand. It was one of those rare nights where you could really feel a community of New Yorkers – book store freaks, old and new

punks, a packed summer forest of

people who were there, not for any spectacle, but to hear words from someone they love.

I saw the band play in Prague at the Ministry of Culture, a much despised official building where, for years, people had had to listen to speeches by the Totalitarian government. For

the first half of the show, the

audience sits frozen to the plush seats, listening to the show through a grim echo. The band chips away and pushes and pushes against a wall of polite reverence. I think it's a lost cause until finally, some people start

to rise, first one far side, then another, then the very front. They know every word, which they probably learned in the '70s and '80s through totally illegal bootlegs. Patti holds out the mic. I watch the face of a man screaming every phrase of "Rock N Roll Nigger." The spoken version of "People Have The Power" hits purest incantation here: reminder and threat and joy. The place erupts, and I can't remember when I've cried like that at any show or felt the politics so heavy in a building's walls.

There's a false assumption that people who take their work seriously

take themselves too seriously.

Sometimes I think she's more of a joker than people would ever imagine. Sometimes she might also be full of it. You can bet the same of Rimbaud or Genet or Jackson Pollack. They become perfect only in their distance, when we can't smell the shit on their shoes. Sometimes she might miss the mark, strike a wrong pose, stumble. The courage is to shoot the arrows anyway, the

necessity of laughter, the need to burn, the crazy mixture of the fuel....

Patti knows the old songs on the

radio, the '40s and '50s stuff, and the old movies too. I've been in a car with her and found her singing along to some forgotten oldie. Her mom's music maybe, but also pop as a chain going way back – to New Jersey, to Paris, farther back still. As if poor dead Artaud had somehow made it to Seaside Heights, NJ in '49 or '57 or '62, stood on the fringe of the midway, and comforted himself with a transistor radio – and Patti

was there and could see him....

I'm listening to "We Three" and realize that it's a sweet and complicated doo wop song.

Opening for Dylan at the Beacon show, Patti looks out over the theater and, seeing that a lot of people haven't yet taken their seats, she remarks, "I see a lot of empty seats out there – those must be for Bob's

henchmen."

No slur is intended. It's a reproach to the very seriousness with which it might be taken. I think Patti said it because it came into her mind.

Patti Smith is funny as hell. And Patti Smith was, is, and will always be, a badass.

So, we live in a world that's still scared of its fags and its niggers and even of poetry as a worthwhile force and a daily tool. What excites me most about Patti Smith is that she's dragging a tradition with her; dirtying up the limelight with books, age, and humor. It's a tradition that says, yeah, I'm a hero because anyone can be

and because I got in line behind all

these other heroes. It says, Brancusi, Bresson – maybe you might want to check them out, show some respect. It says that in the (crooked) line with the weirdos is a good place to be, that there is a knowledge to be shared and passed along. It reminds us that Alfred Jarry was a punk, Hendrix was a punk, little kids are inherently punks, that we all have

access to a madness that can save as well as it can destroy.

If there are two words that sum up Patti Smith for me, they are "abandon" and "hope," but never the two together.

In his invitation to write for this project, Michael tells us that the book will be more "snapshots than fine art photography." I thought that was funny, since his photography is largely about his refusal to believe in

any such distinction. I don't think Michael takes photos in order to

"make art." He knows that art can come, but it's a secondary thought, the vapor trail behind the plane. Michael takes photos because he needs to; to gather his thoughts and friends and memories around him. He takes them as a way of traveling through, of breathing. And during this time with Patti, he was breathing well.

Jem Cohen

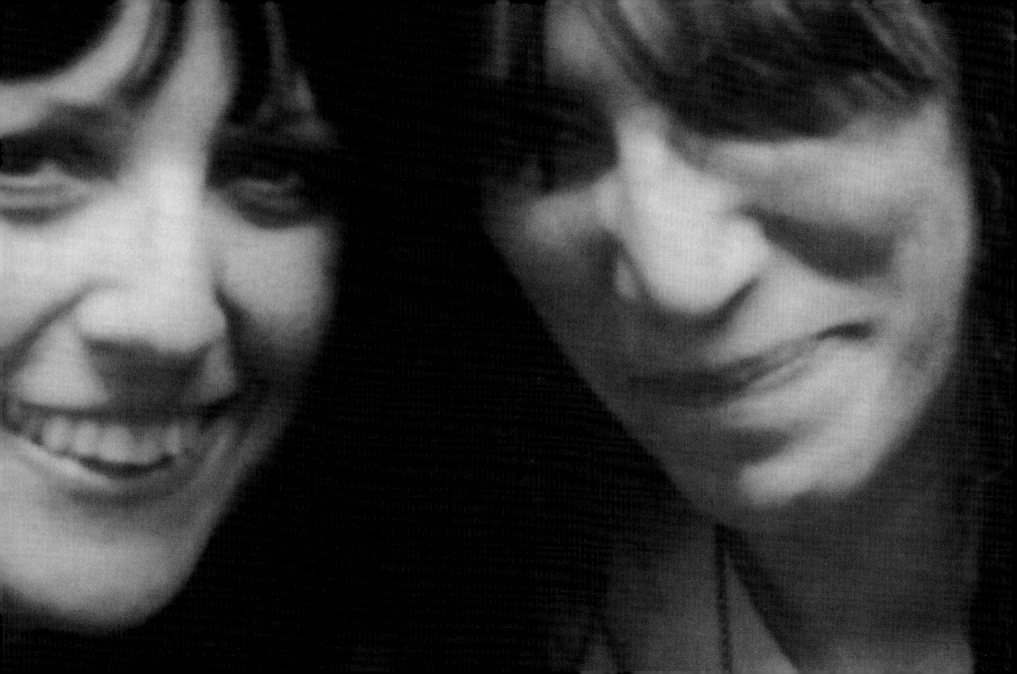

Chiaroscuro: an arrangement of light and dark parts to create a pictorial vision.

Patti Smith was an uncompromising

black and white vision at first, especially after all that mellow, corporate schlock coming out of

California and even David Bowie's spiky orange hair and fluffy pink feathered boa. Along with Tom Verlaine and the Ramones and the rest of them, she invented our own rock scene – CBGB's, Reno Sweeney's, the Diplomat, upstairs at Max's, the new Velvet Underground, stark, stark. She was very Paris street urchin in a black wool cap,

white t-shirt, black sweater, black velvet jacket, skintight blue jeans,

string around the wrist, blue-green leg warmers, striped Peruvian wool socks and black ballet slippers and it still was all black and white. It was anti-fashion but she loved fashion: a self-admitted cloth fetishist, she'd run into Bendel's just to touch silk and cotton and cashmere. She wanted lots of Rastafarian t-shirts, 12 pairs of custom made pants and a mink jacket and she always read *Vogue*.

"But I won't be satisfied until they

give me a whole spread," she said in 1975.

When she broke her neck after she fell from some stage somewhere,

she was in bed in the Fifth Avenue

apartment for a long time, wearing that neck brace and surrounded by half-eaten hamburgers, styrofoam coffee cups, books, books, books. We would talk: girl talk, music business talk, interview talk. She always could do what she called the transcendent interview or the Earl Wilson interview; the big metaphysical subjects and the quick gossip sound bites. Tough, smart, giving good advice, no nonsense.

Then the phone would ring and it

would be Fred, and her voice would turn into all little girl flirt.

When she and Lenny first started out, the poetry was rock and roll and the rock and roll was poetry and she

set us all on fire. Instant recognition. The same way we never wanted to skip a night at Max's because we thought we'd miss something, whenever Patti performed, you couldn't miss it because you knew you were in on something. She said

she imagined herself disintegrating in the light, playing electric guitar. She couldn't be phony onstage. She was funny onstage. One night at the Bottom Line – where they didn't let the performers drink liquor onstage –

she jumped across the stage onto the tables during her set, grabbed my hand, and made me go with her

to the bar to buy her a drink. One night in Central Park, mid-concert, she took me to the side of the stage and asked me to shield her, she had to pee. She was brand new, important, alarming, romantic, sexual, an eight millimeter home movie that we were sure would touch the world.

It did.

Now, no longer the angry punk ingenue, she's older, wiser,

compassionate, commanding, still on fire – with a new voice that seems to have come from somewhere else. "It's Fred," she told me. "After he died, we had a tribute to him at the Mariner's Church in Detroit and I started to sing and this voice came out. I had to turn around, I didn't know whose it was." She met the Dalai Lama last year and sang with Dylan wearing a long dress Michael bought her, eyes shining, standing as if in prayer, blushing, little girl flirt.

"If I thought that even in a small way somebody might treasure my work," she said, "it really makes me happy. To inspire people is the best thing you can do, it was the best thing people did for me." All around her, ghosts dance: Fred, Todd, Richard, Robert. Learning to walk the stage again.

And this past year, 20-whatever years later, she got that spread in *Vogue*.

Lisa Robinson

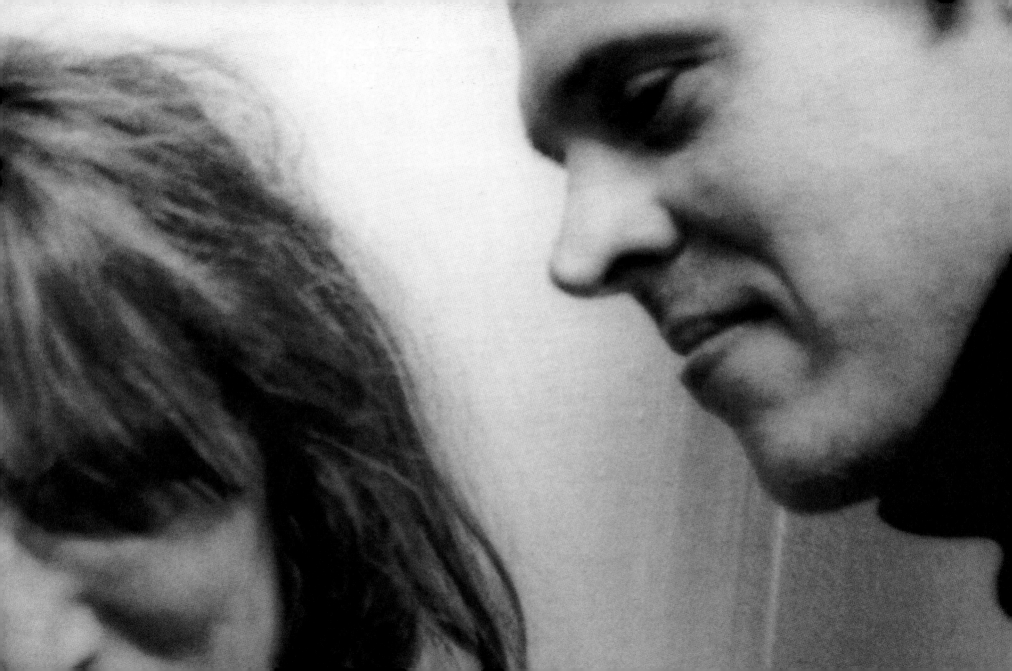

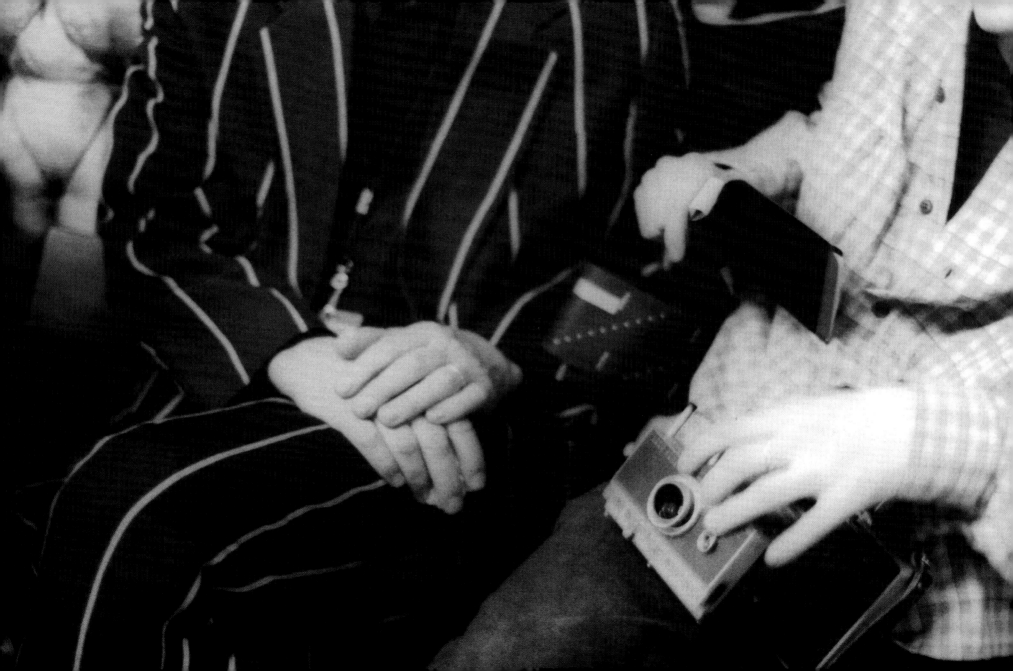

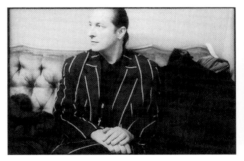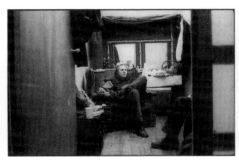

It's our third show, the first in Boston, and I can feel the momentum of our live energy starting to gather speed. I look down at my hands during the solo of "Rock N Roll Nigger." My fingers are cascading across the fretboard, moving of their own volition, spinning out notes. I watch them almost as an observer; they seem to belong to another dimension, possessed.

I never expected to be performing this song again. Even when it came up in practice a few days ago, before the Dylan tour started, we mostly played it for a goof, because it's a rush to barrel

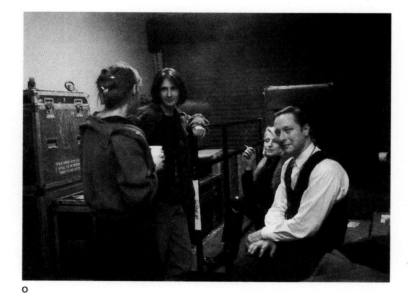

o

through its rapid-fire changes, and because its inner truths seem unchanging.

Now it's for real, and so are we. On the bus again. Though it's great to be out and about, most of my attention in these shows has been directed internally, a continual monitoring of our band energy, how to communicate across a larger stage, how to present renewed the music of our past and future. The individual scorecards of each night – and the audience response to them – are more a way to measure our collective growth. I look for

...nny Ka...

is lifespan hold

directional signals within the band: the lock of the rhythm section, the blend of guitar textures, the navigation of each song map, the practiced switch of instrument and mood.

We play tightened up, downbeat at eight, only given 45 exact minutes. No breathing room for the usual ramble. Sometimes the songs pass in a flurry; sometimes it takes forever to visit each marker in the set. No matter. Each show is a learning, a surer grasp on our inner dynamic, and every once in a while, if we're lucky, the music takes over and makes us crazy.

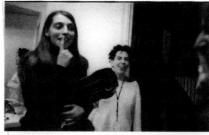

At the end of the solo, sway bar in hand, I spin around and face-off my amp for the first time since the tour started. It impels me: I rush toward it and ram the guitar into its quartet of speakers, feeling it howl and scream and groan back at me in joy and release, overtoning a primeval frequency response.

So we return to return, spiraling our energy, doubling around to cover our tracks and start anew. What, I wonder as the feedback spreads its wings around me in a trebling embrace, will this lifespan hold?

Lenny Kaye

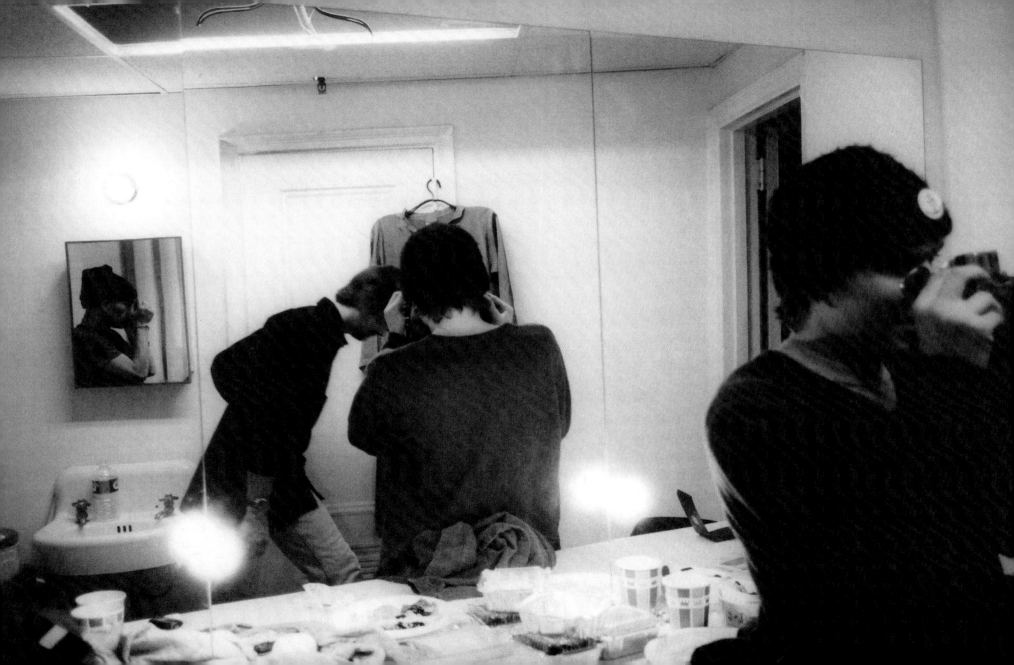

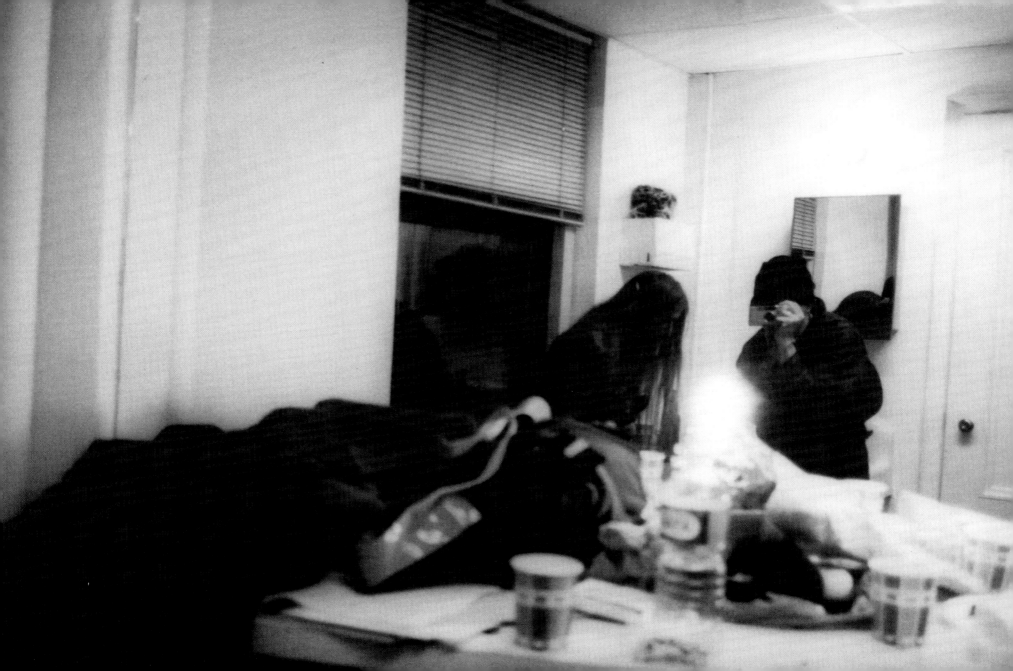

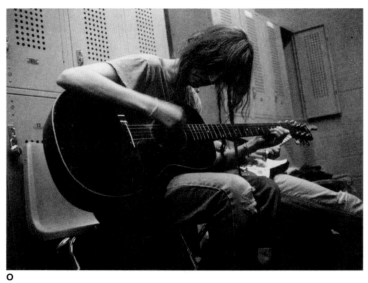

o

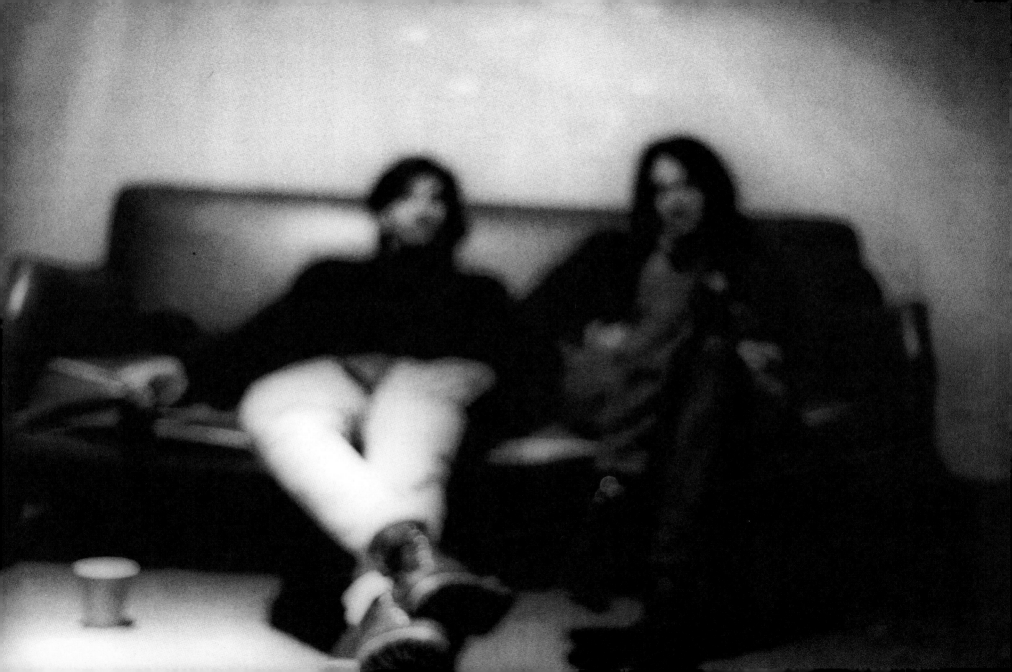

THRILLER

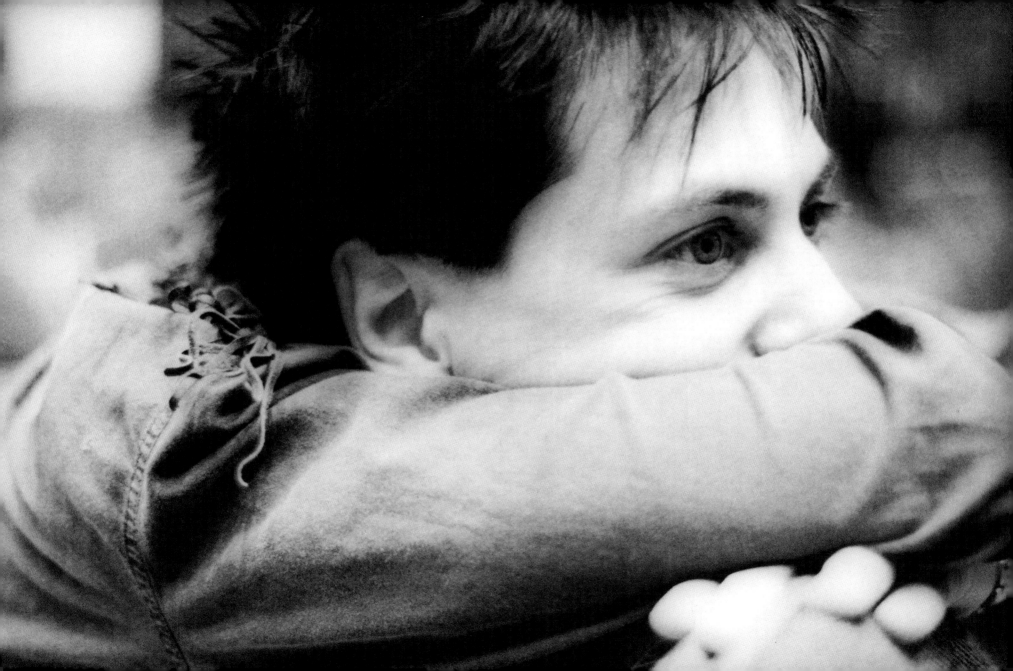

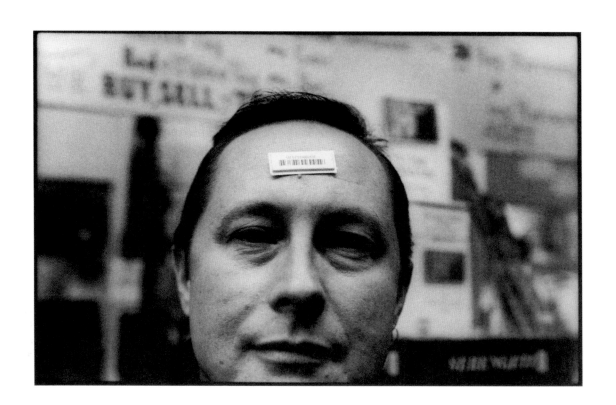

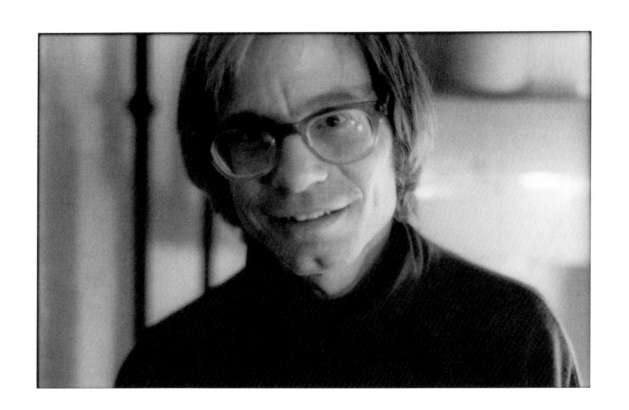

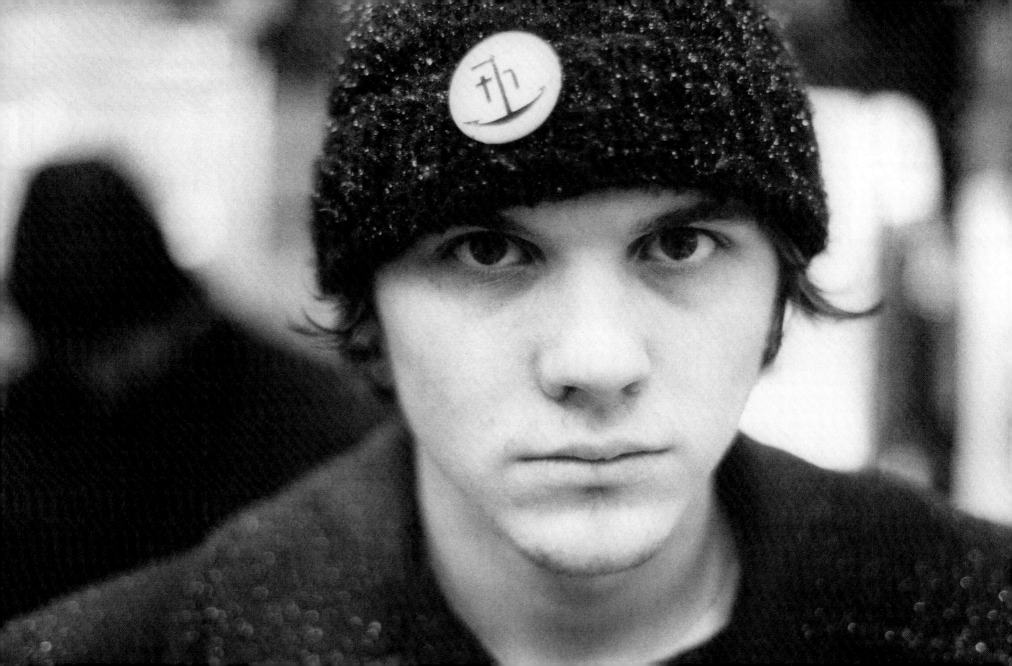

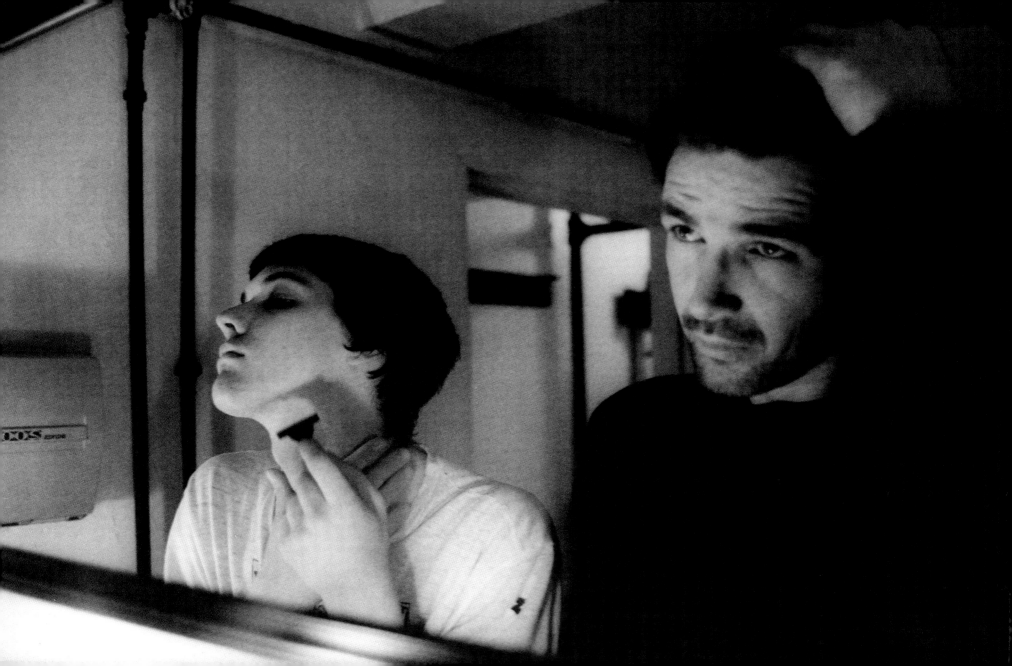

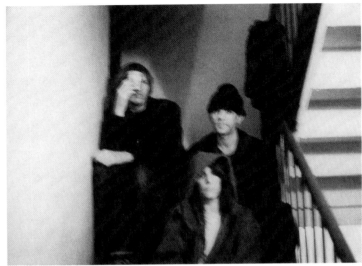

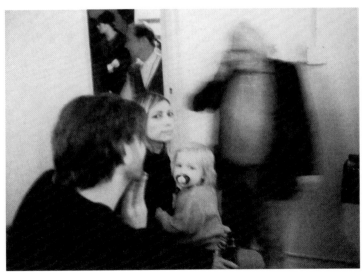

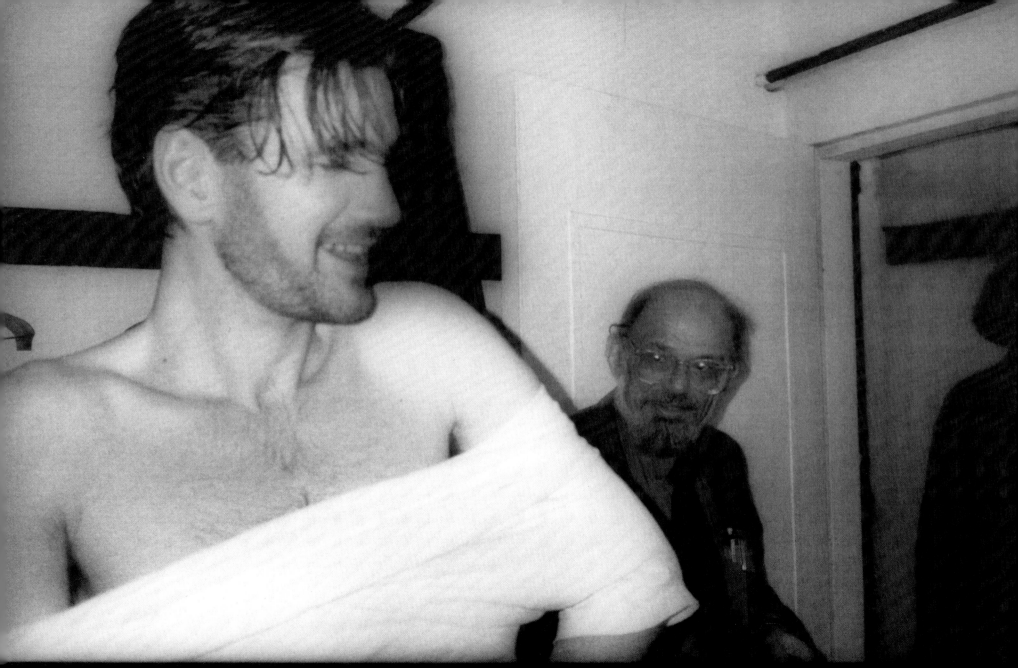

you were amazed to find out i too had
fantasized with my girlfriends about
which beatle was my boyfriend, which
rolling stone was cooler brian or keith.
before knowing this i was watching you
onstage thinking about you as a young
girl maybe fantasizing about brian so
bad that you wanted to inhabit his body.
and a little later about dylan. how your
desire set you off on this journey to
experience what they seemed to hold
about them as magical, unattainable.
you all the time feeling human and
clumsy and then more graceful, sexually
powerful – and at one with a certain
vulnerability. it is a gift to believe in this

at one time girlish desire now
transformed into spirituality. it is far
beyond the original attitude (and
inspiration) of arrogant rock & roll male
sexual posturing. seeing you on stage
next to dylan, one of your heroes, there
seems no tension within you between
what is male sexual strut and the sorrow
of your life of the last few years. they
vibrate together in an energy that made
me feel you'd somehow surpassed your
model and found yourself alone except
for the genes of this evolution that your
children possess and that made me cry

– for joy of course.

kim gordon
nyc 10/18/97

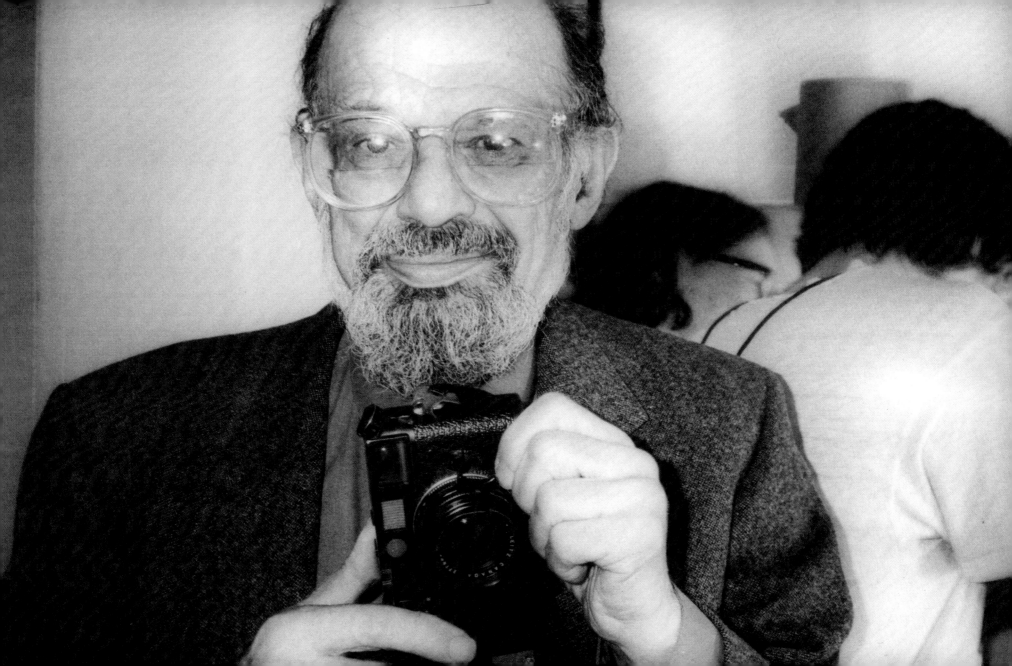

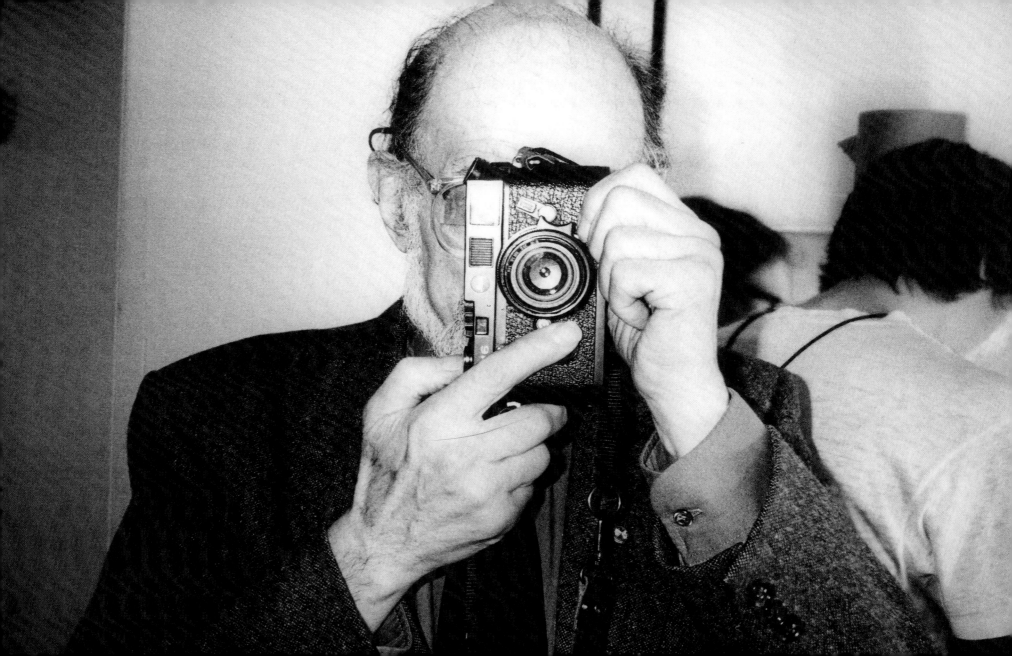

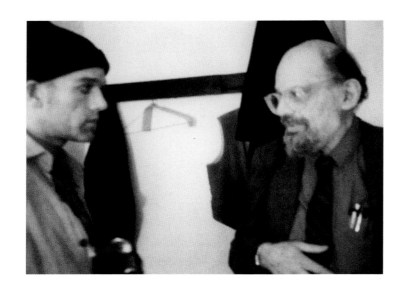

°x2

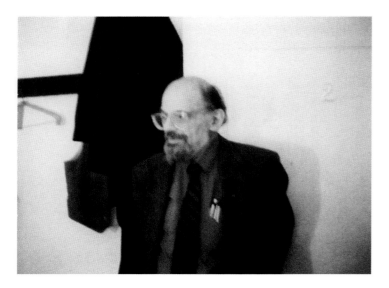

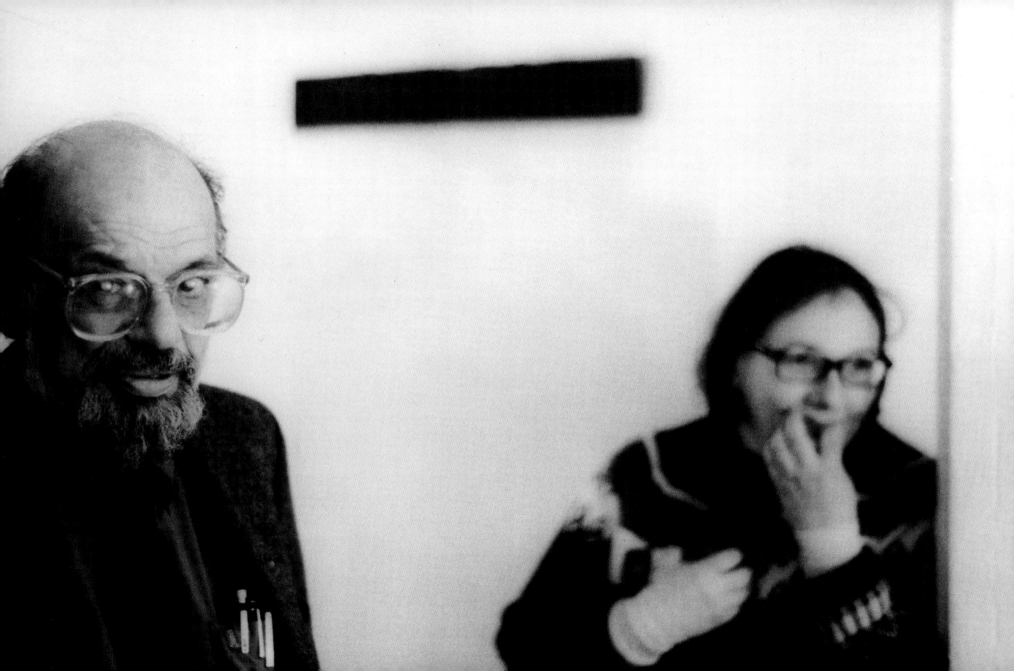

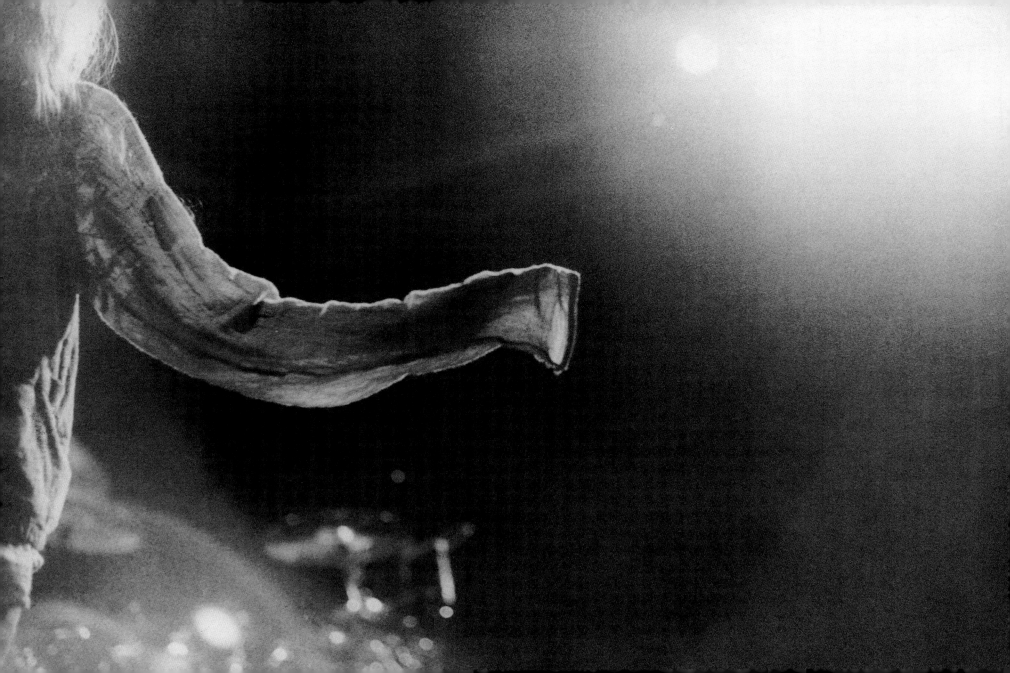

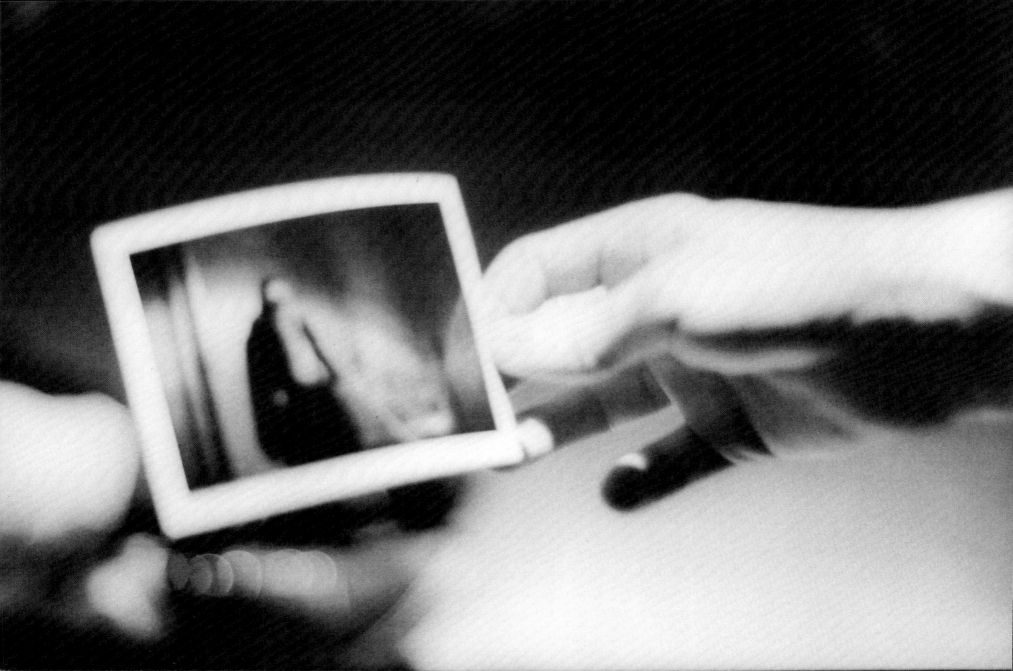

My husband Noel and I met Patti Smith

in Berlin in September 1994 at a "Peace University" where the Dalai Lama was a main attraction.

Patti knew our son Adam (MCA of the Beastie Boys) and he introduced us at the opening night dinner. Patti was so happy, so open and direct, she put me in mind of a little girl. When she sang the next day, she left me with tears in my eyes.

When we saw her again, it was a year later, in the lobby of the Philadelphia Art

Museum. An overflow crowd had come to see the show of Brancusi's sculpture.

Noel spotted Patti with some of her tourmates and said hello. We got that same radiant smile.

Leaving the museum, we tried to arrange

ourselves for a farewell photo. Patti and company were nearby, and she joined us for this memorable moment of family, culture, and sculpture.

Frances Yauch

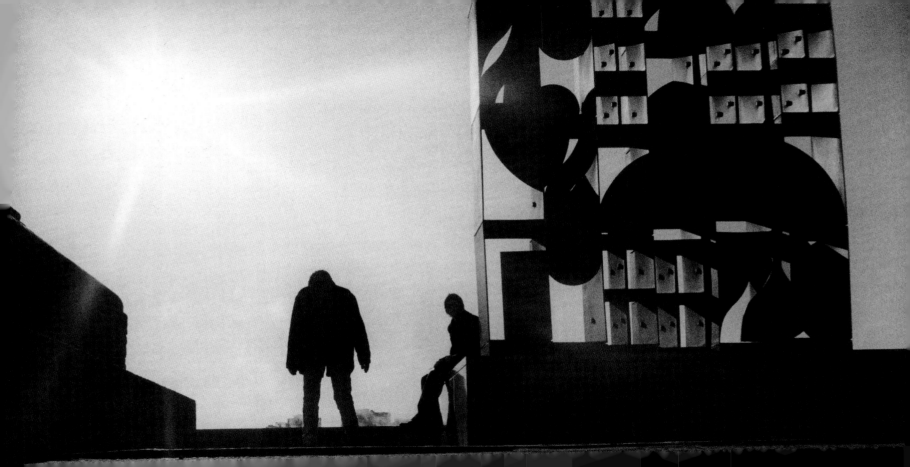

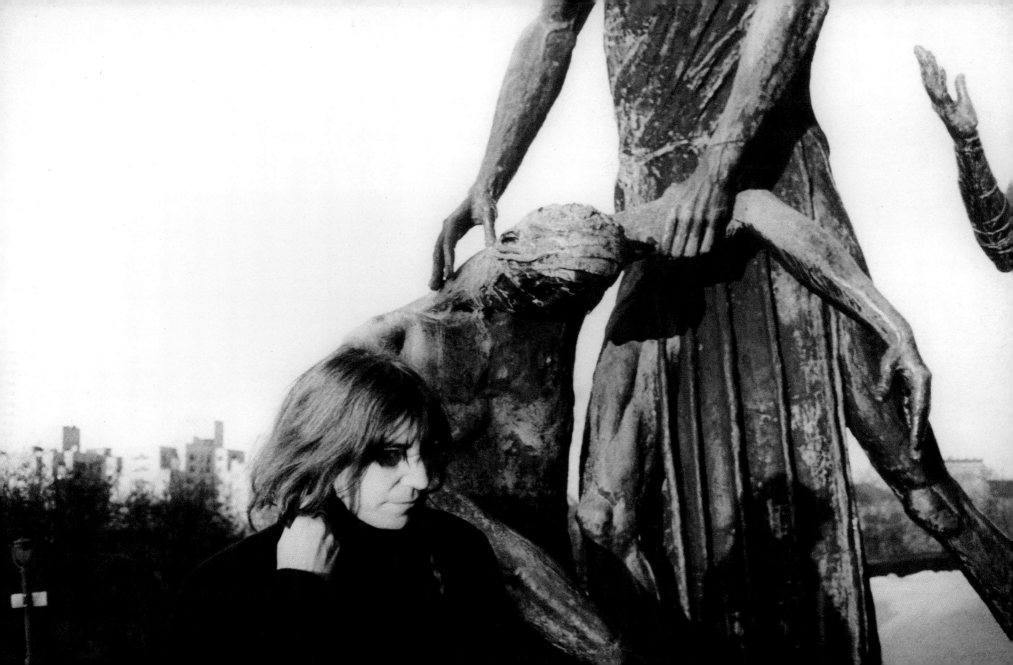

o

o

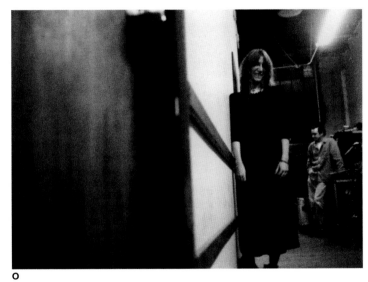

o

There was once a girl who felt
nothing but alone.
Alien, estranged, feeling no one spoke
for her, or her kind.
She found refuge in one from afar
who ventured out and spoke.

This same girl found her own voice
and her own strength and ventured
out and spoke for herself.

Time passed and she, spent by fate,
fell silent. Slowly, through
the encouragement of others – those

seen in the leaves of this book –
she found her voice a second time. It
was then, petitioned by
the one from afar, that she set out
with them and spoke again.

On the last day of this venture, on
behalf of all, she went to offer
thanks.
He opened the door and they
conversed, somewhat awkwardly,
with mutual
regard. She exited leaving him to his
domain, his dignity unchallenged.

And she returned to the domain of
her people. Desiring nothing more
than to thank them as well.

Though in the face of all the love, the
laughter and loyalty, found herself
speechless.

Patti Smith

...imes

...l photographs

72

PRINTED IN

U.S.A.

On the Road with Patti Smith by N

Intro: Michael Stipe

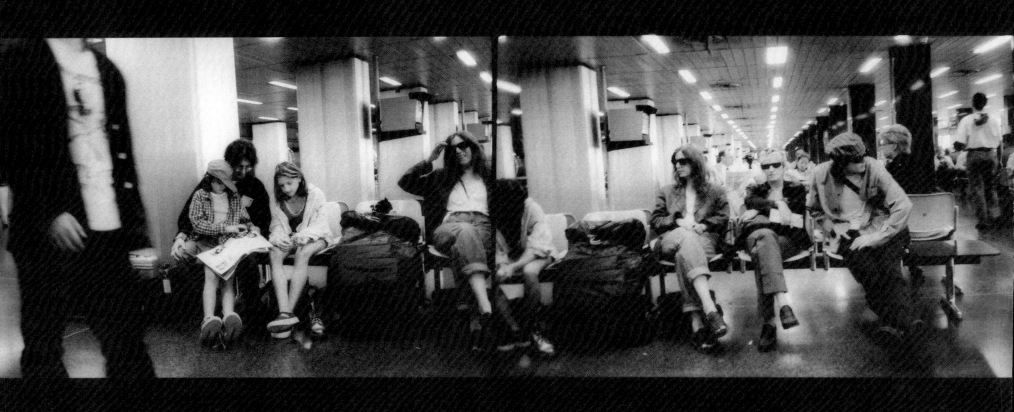

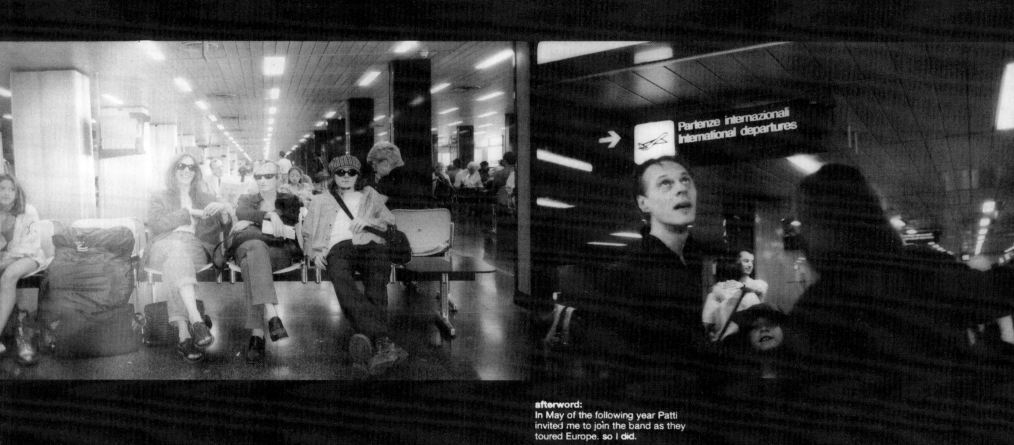

afterword:
In May of the following year Patti
invited me to join the band as they
toured Europe. so I did.

AKASHIC BOOKS

Akashic Books
PO Box 1456
New York, NY 10009
info@akashicbooks.com
www.akashicbooks.com

Michael's list:

Thank you to Oliver Ray for
contributing your eye to this book.
Ian McFarlane printed all the photos
in this book and did a fucking great
job. Thanks Ian.
Thank you Dad for trusting me with
your Nikon when I was 15.
Thank you to my entire family for
your love and trust and support.
I love you all so much.
Thank you to Susan H. Bodine for
guidance and legal counseling.

Thank you to Mark Blackwell,
Chris Ashworth,
Marvin Scott Jarrett,
Jaclynn Jarrett,
and everyone at Ray Gun Publishing
for helping me make this real.
Thank you to everyone who wrote
pieces for this book:
William S. Burroughs, Oliver Ray,
Paul Williams, Jutta Koether, Tom
Verlaine, Thurston Moore, Jem
Cohen, Lisa Robinson, Lenny Kaye,
Kim Gordon, Frances Yauch, and
Patti Smith.

Thank you to Peter, Mike and Bill;
and to Bertis and everyone at R.E.M.
– thank you Meredith for organizing
everything.
Thank you to James Grauerholz.
Thank you to Douglas A. Martin for
believing in my pictures so much.
Thank you to Patti Hudson.
Thank you to Jessie Zoldak.
Thank you to Raymond Foye.
Thank you to D.O.C.
Thank you to Jim Herbert.
Thank you to Jimmy Vines and the
Vines Agency.

Thank you to Geoff Kloske + Little, Brown
Thank you to Linda Hopper who helped
make something of the shitty enlarger.
Thank you to the following
photographers for inspiration and debate:
Michael Ackerman
Jeremy Ayers
Lance Bangs
Chris Bilheimer
Mark Blackwell
Christy Bush
Kim Caputo
Helena Christensen
Jem Cohen

Cynthia Connolly
Anton Corbijn
Douglas Coupland
DJ
Dominic DeJoseph
Brook Dillon
Stephen Dorff
Tom Gilroy
Allen Ginsberg
Charles Greenleaf
Lukas Haas
Jim Herbert
Michael Lachowski
Jeff Luckey

Sally Mann
Carl Martin
Douglas A. Martin
Ian McFarlane
Jim McKay
Michael Meister
Christopher Munch
Rain Phoenix
Kai Riedl
Karina Santos
Randy Skinner
Gus Van Sant
Wolfgang Tillmans
Jaime Willett

Thank you to Lenny Kaye, J.D. Daugherty, Tom Verlaine, Tony Shanahan, and Oliver Ray for letting me jump onboard.

and finally,
thank you Patti for your voice and your vision, and for trusting me. words sound stupid. look into my eyes.

People in this book in order of appearance:

Patti Smith
Tony Shanahan
Oliver Ray
me
Tom Verlaine
Jutta Koether
Jessie Zoldak
Jackson Smith
Mark Edwards
J.D. Daugherty
Lenny Kaye

Tim Robbins
Lisa Robinson
Stephanie Kaye
Annalea Kaye
Anastasia Pelakias
Paul Williams
Gregory Corso
Thurston Moore
Kim Gordon
Coco Hayley Gordon Moore
Allen Ginsberg
Elsa Dorfman
Frances & Noel Yauch and friends
Jesse Smith

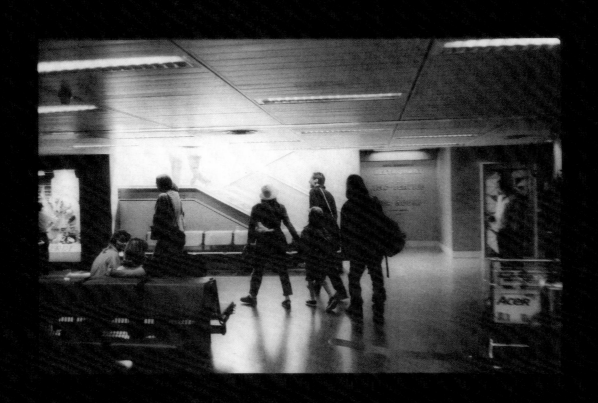